IMAGES
of America

# SPRINGFIELD

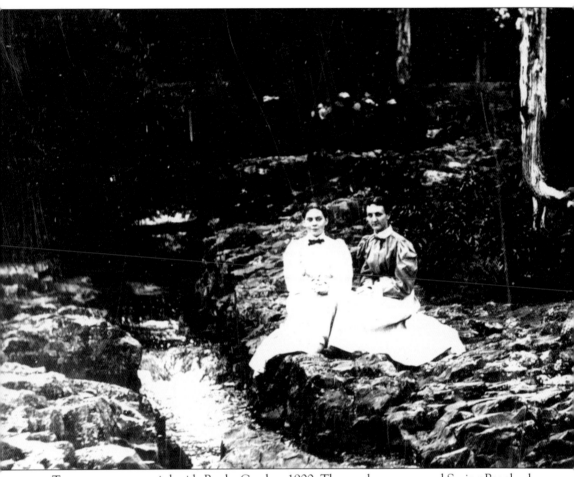

Two young women sit beside Rocky Creek *c*. 1900. The creek was renamed Spring Brook when a land developer subdivided adjacent land into house lots. Today, some people call the stream Briant's Brook because it flows into Briant's Pond.

IMAGES
*of America*

# SPRINGFIELD

Jean-Rae Turner and Richard T. Koles

ARCADIA

First published 2004

Published by Arcadia Publishing,
Charleston SC, Chicago IL, Portsmouth NH, San Francisco CA

Printed in Great Britain

Library of Congress Catalog Card Number: 2004107608

For all general information, contact Arcadia Publishing:
Telephone 843-853-2070
Fax 843-853-0044
E-mail sales@arcadiapublishing.com
For customer service and orders:
Toll-free 1-888-313-2665

Visit us on the Internet at www.arcadiapublishing.com

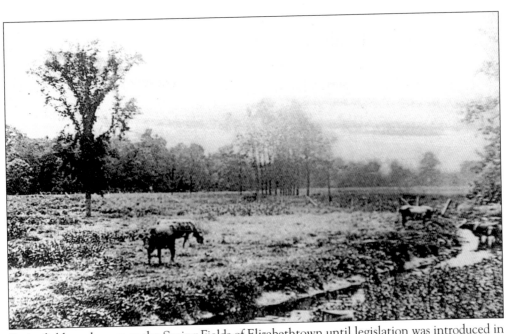

Springfield was known as the Spring Fields of Elizabethtown until legislation was introduced in the state legislature in 1793 to form the township of Springfield. The name was selected because the area was known for its large number of springs.

# CONTENTS

# ACKNOWLEDGMENTS

Many people have assisted in compiling this book. We want to thank the members of the Springfield Historical Society, especially president Margaret Bandrowski, Donald and Eileen Auer, William Culp, Janice Bongiovanni, and Howard Wiseman, who permitted the use of their photographs and assisted with historical information. Special thanks go to the following: township consulting engineer Robert C. Kirkpatrick; township engineer Samuel Mardini; zoning officer Richard Cohan; Chief William Chisholm and other members of the Springfield Police Department; Chief William Gras and Capt. Thomas Ernst of the Springfield Fire Department; Daniel Bernier of the Union County Department of Parks and Recreation; Union County clerk Joanne Rajoppi; Chief Lester Sargent of the Union County Sheriff's Office and president of the Union County Historical Society; Michael Yesenko, Robert Fridlington, and Hazel Hardgrove, past presidents of the Union County Historical Society; William Frolich; Douglas Killian; township clerk Kathleen D. Wisniewski; Raymond Schramm; Theresa Herkalo of the Springfield Recreation Department; William and Eleanor Gural; Rev. Frank Ostertag; Rabbi Joshua Goldstein, spiritual leader of Temple Sha'aray Shalom; Kathy Gross; Charles Helfrich; Diane S. Bedrin; Beatrice and Jack M. Slater; Ethel Smith; Robert Kirkland; and Carol Efrus Degan.

For permission to photograph the Donald Palmer Collection, we thank Susan Permahos, director of the Springfield Public Library, and the staff of the Newark Public Library's New Jersey information section, including assistant library director Charles F. Cummings, Robert Blackwell, Valerie Austin, James Osbourn, April Kane, and Willis Taylor.

This book is dedicated to Howard Wiseman, a founder of the Springfield Historical Society who died in December 2003, while this book was being prepared.

# INTRODUCTION

When I stand in the parlor of the historic Cannon Ball House in Springfield, I notice that the eyes of all those waiting at the traffic light are focused on the old yellow house between the two office buildings. I hope they wonder about the stories the old house has to tell; often they visit to hear about it. Most are unaware of the role the house played in the battle of Springfield in June 1780 and are fascinated to see the cannon ball lodged in its walls. I hope the house reminds them that Springfield has not always been as it is now and perhaps inspires them to be curious about life in the good old days.

For Springfield, the good old days began with settlement in the early 18th century in the Spring Fields west of Elizabethtown, once the Colonial capital of New Jersey with lush forests and many streams and meadows. Springfield was much larger then. It was whittled down in size as surrounding towns were formed out of it. There were mills for papermaking and lumbering, along with farms. By 1793–1794, the township had separated from Elizabethtown. The Morris Turnpike was built in 1801 between Morristown and Elizabethtown on an old trail; at the same time, other trails became permanent roads.

The quiet community, however, had some problems. Early records of the township committee make note of provisions for the poor and the roads and fines for failing to fence swine, cattle, and wandering dogs. Despite its rural location, residents came from many parts of the world, as shown by the names on the stones in the five old cemeteries.

By 1830, Springfield had a population of 1,653, including 95 single men and 220 horses and mules. There was one church, three taverns, and a distillery. The farms had been replaced by nurseries by the late 19th century. Many fine homes stood here, holding distinguished residents including doctors, judges, and prominent businessmen. A land developer described Springfield as "Paradise."

Almost all evidence of these good old days has been removed or obscured by the sprawling development of the 20th century and the invasion of superhighways. We hope this book will help to remind us of what was once a charming rural community, for its origins and early life can still be discerned with guidance and determination. We need to honor that past as a source of strength for the future, even as what remains sometimes seems to vanish before our eyes.

—Margaret Bandrowski
President of the Springfield Historical Society

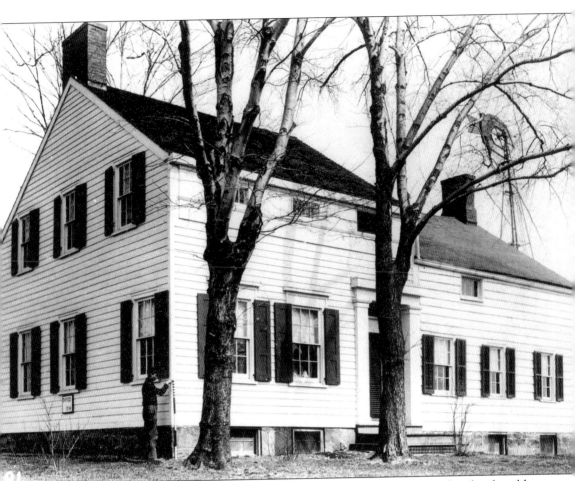

The Swaim House on South Springfield Avenue, built c. 1740, is believed to be the oldest dwelling still standing in the township. The house escaped damage during the Revolutionary War because of its distance from the center of the hamlet and its use by the British for storage of supplies during the battle of June 23, 1780.

# One
# THE SPRING FIELDS
# OF ELIZABETHTOWN

In Colonial times, the Elizabethtown Associates divided the land amongst themselves. Each person received a town lot, meadowland, and woodland. The Spring Fields of Elizabethtown were covered with trees. The woodland was used for firewood and to build houses, barns, and sheds. The first permanent settlers are believed to have moved into the area in 1717. Only three dwellings inhabited the Spring Fields, and another three stood between the Spring Fields and the center of Elizabethtown. Early settlers dammed the streams for water to power their mills. Some 10 mills are reported, but their names and locations have been mostly lost in time. One was near Morris Avenue on the Rahway River, and another was near Milltown Road on the same stream.

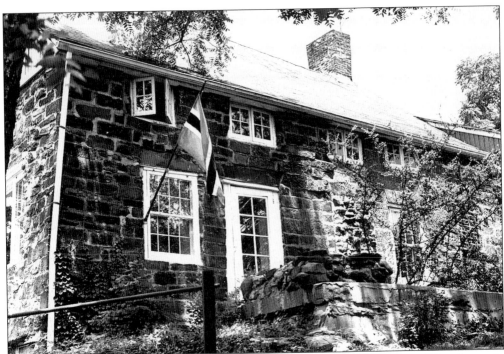

The Sayre House on Old Coach Road is a unique stone house for this section of New Jersey. It is believed that Gen. George Washington slept in the house for a week before the battle of Springfield on June 23, 1780. Other historians say that he rode up Old Coach Road and asked only for a drink of water. Since Revolutionary days, it has been used as a residence, an antique shop, and an art gallery. The property is now surrounded by signs advising visitors not to trespass. It stands beside Sayre Lake, half of which was filled in when Route 78 was built.

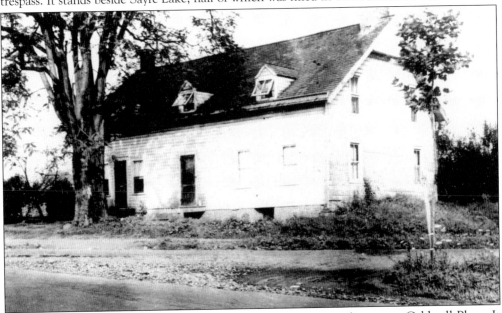

The Joseph Tooker House once stood on present-day Mountain Avenue at Caldwell Place. It was razed in 1980 in order to build a modern office building on the site.

The First Presbyterian Church was organized in 1745 and was the only church in the community for 90 years. The first sanctuary, initially led by Rev. Timothy Symmes, was in present-day Millburn. A new church was built on the present site in 1761.

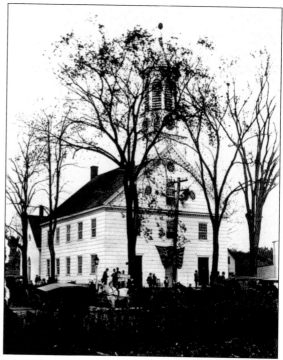

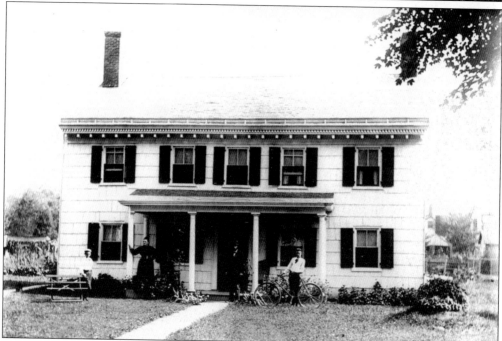

The Cannon Ball House, which was used as a hospital by the British during the June 23rd battle, was built either in 1741 or 1761 by Dr. Jonathan Dayton. Most historians believe the second date is correct. Dr. Dayton, a cousin of Gen. Elias Dayton, died in 1778. After his widow briefly operated a tavern there, the house changed hands many times and was finally donated to the Springfield Historical Society in 1953.

Springfield was once mostly covered by trees and shrubs. And much of it in this 2004 photograph is still covered by vegetation. Today, Springfield claims 5.2 square miles ranging from 74 feet above sea level at Fadam Road to 487 feet on High Point Drive in the Baltusrol Top area. Most of Springfield lies below First Mountain, sometimes called Baltusrol Mountain.

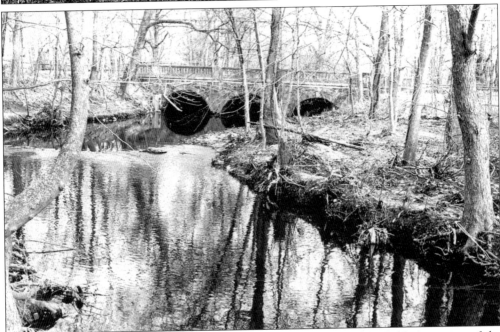

This is a view of the Rahway River from the site of the battle of Springfield. A portion of the present bridge over the river may be observed through the tree trunks in the center of the photograph. Two hundred years ago, the road wound west of the present road and was only wide enough for two wagons to pass. The street has since been broadened and straightened. This bridge is east of the Revolutionary War bridge, which was destroyed by Continental soldiers and militia in 1780.

Gen. George Washington used Bryant's Tavern near Bryant's Pond (pictured) as his headquarters during a portion of the battle. Today, the pond is within a county park just over the Springfield line in Summit. The name is frequently spelled with an *i*, making it Briant Park.

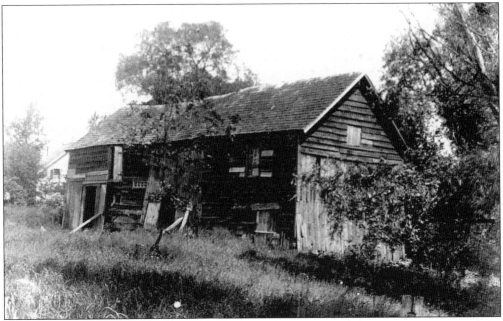

This old barn, similar to those built by farmers in the 18th century, stood on the site of the battle of Springfield on Washington and Morris Avenues for many years. It was razed when Morris Avenue was straightened and a new bridge was built. Washington Avenue, named for the general, leads to the location of the original bridge. The area along the river is now part of the Rahway River Park, a county facility, and features a ball field.

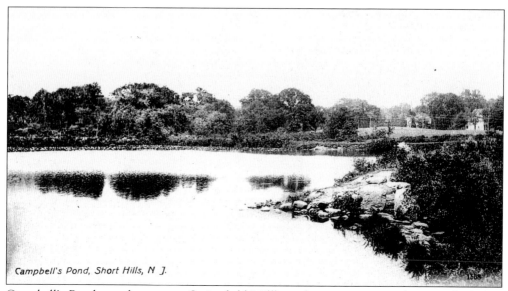

Campbell's Pond, Short Hills, N.J.

Campbell's Pond, on the present Springfield-Millburn line, was apparently created when a stream was dammed for power for Campbell's Mill. The mill was one of several in the Millburn-Springfield area. In the 19th century, it was known as an excellent place to ice skate. The area was filled in when the dam and mill were removed. Houses stand on the site today on Short Hills Avenue.

This is a view of Old Coach Road as it looked in 2004. The road is still dirt, the mud ruts are gone, and the road is wider.

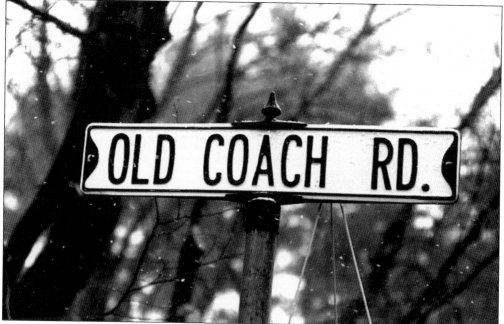

Old Coach Road, off Baltusrol Road, allows access to the Springfield portion of the undeveloped Hidden Valley Park. The county park covers 81 acres on the Springfield-Summit line and includes the old Houdaille Quarry, formerly known as the Stewart Hartshorn Quarry. The Springfield portion covers more than 50 acres.

This section of Old Coach Road is near the Jefferson School, off Ashwood Road, in Summit. The woodland includes a lake, streams, a marsh, swamp, several ponds, wild flowers, and shrubs. Deer, Canada geese, opossums, raccoons, rabbits, skunks, groundhogs, and an occasional red fox can be seen. A playground is being built on the Summit side, which also contains a disposal area for Union County leaves. A two-mile hiking trail is planned between Route 78 and Mount View Avenue in Springfield.

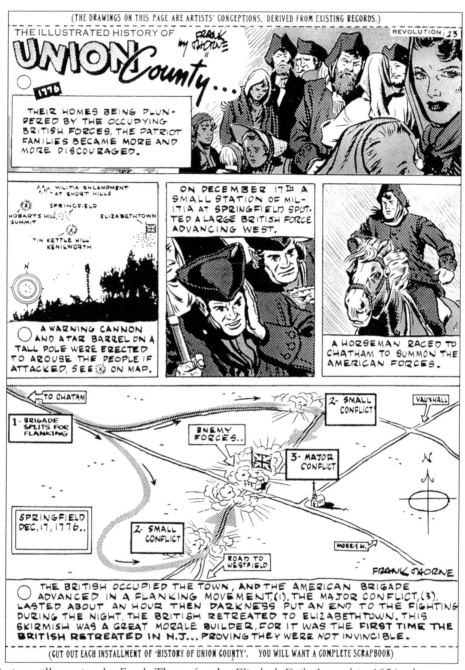

This is an illustration by Frank Thorn for the *Elizabeth Daily Journal* in 1954, observing the paper's 175th anniversary. The commemorative edition traced the history of Union County. This page depicts the first battle of Springfield on December 17, 1776, when British troops attacked the Continental Army and the two battled until dark. The Continental Army camped at Bryant's Pond, planning to resume the fighting when it was light. When dawn came, they discovered the British troops had retreated to Staten Island during the night. It was the first time during the war that the British had fled the battlefield, a great morale booster for the Continental Army.

# Two

# THE BULWARK
# OF THE REVOLUTION

The Spring Fields were in the path of the British and Hessian armies' attempts to seize Continental supplies stored in Morristown, behind the Watchung Mountains and several swamps. During the hostilities between the American colonies and Great Britain, there were many attempts by the British forces and their mercenaries to pass through the gaps in the mountains and seize the supplies. Included were three attempts: one in December 1776, during Gen. George Washington's famous retreat from White Plains to Washington's Crossing on the Delaware River; another on June 12, 1777, during the attacks from the Middlesex County area; and finally the invasion of June 7–23, 1780. Each time, the enemy forces were faced by determined militiamen and Continental troops eager to preserve their freedom.

The most famous of the attempts was in June 1780, when Gen. Wilhelm Knyphausen, the Hessian commander, learned that troops at Morristown were in poor physical condition and had mutinied against their leaders. On June 6, 1780, he ordered that a bridge of boats be placed across the 500-foot-wide Arthur Kill from Staten Island to Elizabethport and that planks be placed atop them so horses and his 5,000 men could pass. On June 7, British and Hessian troops marched up Water Street (now Elizabeth Avenue). They were temporarily disorganized when their commander, Gen. Thomas Sterling, was shot by young Moses Ogden. He was wounded and subsequently died. The invaders reformed and advanced as far as the Rahway River, where they were halted by Col. Elias Dayton and his 3rd New Jersey Regiment. The sun fell after two hours of fighting, and the shooting stopped. The militiamen and Continental Army withdrew to Bryant's Pond to continue the fight the next day. The invaders, instead of establishing their camp, retreated to the Arthur Kill in a thunderstorm. They camped until June 23, raiding Elizabethtown during that period for food for the troops and grain for the horses. On the appointed day, they once more advanced up Galloping Hill Road toward the Spring Fields.

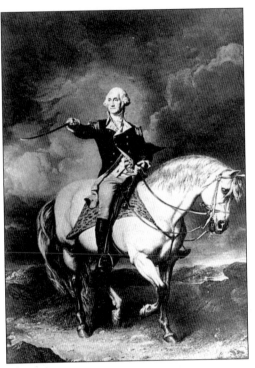

Gen. George Washington directs his troops. Fearing that the British might attempt to capture West Point and cut New England off from the rest of the new nation, he left the Spring Fields before the end of the battle and headed for the Dey Mansion in today's Wayne to watch the forces of British general Henry Clinton, who had arrived in New York City from Charleston, South Carolina, to take command of all British forces.

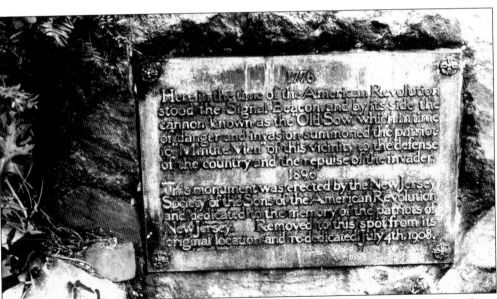

When the guards on First Mountain saw 5,000 British and Hessian troops moving below them, they began firing "Old Sow," the cannon on Beacon Hill (now Hobart Avenue in Summit). In addition, a signal fire was lighted and bells on the churches rung. Militiamen responded from the Mountain Society (Orange), Morristown, Elizabethtown, and hamlets throughout the area. Historians estimate 1,200 militiamen participated in the battle. The New Jersey society Sons of the American Revolution placed this tablet at the cannon site.

This *c.* 1900 photograph shows the interior of the Swaim House on South Springfield Avenue.

The privately owned Swaim House has since been restored to its original appearance.

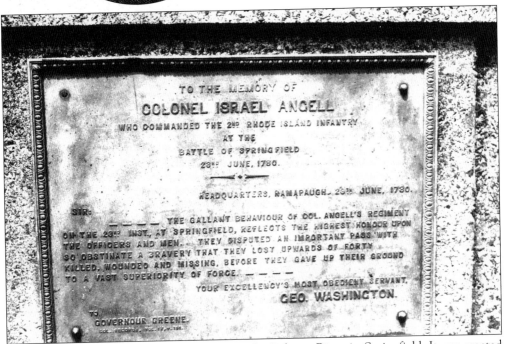

Col. Elias Dayton, a veteran of the Seven Years' War, commanded the 3rd New Jersey Regiment and fought throughout the Revolutionary War. Historians say that he looked like George Washington. At the war's end, he was promoted to brigadier general, the highest-ranking officer in New Jersey. In civilian life, Colonel Dayton was a merchant on Broad Street, near the Old Stone Bridge in Elizabethtown, and held several public offices.

This plaque on Morris Avenue is adjacent to the Rahway River in Springfield. It was erected to honor Col. Israel Angell, commander of the 2nd Rhode Island Infantry at the battle of Springfield. Gen. George Washington wrote at his headquarters at Ramapaugh (Ramapo) on June 29, 1780, "Sir: The Gallant Behaviour of Col. Angell's Regiment on the 23rd at Springfield, reflects the highest honour upon the officers and men." The troops attempted to stop the enemy at the Rahway River and were forced to retreat.

The Rahway River was the scene of intense fighting on both June 7 and June 23, 1780. In 1976, the state of New Jersey placed these blue-and-white signs along the routes of the battles of Connecticut Farms and Springfield in conjunction with the 200th anniversary of the Declaration of Independence. During the retreat of the enemy on June 7, Hannah Ogden Caldwell, wife of Rev. James Caldwell, was killed by an enemy soldier. Her death outraged the supporters of the Revolution.

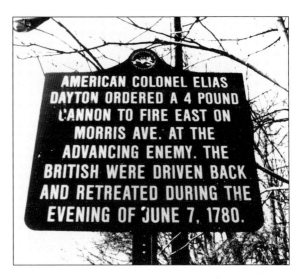

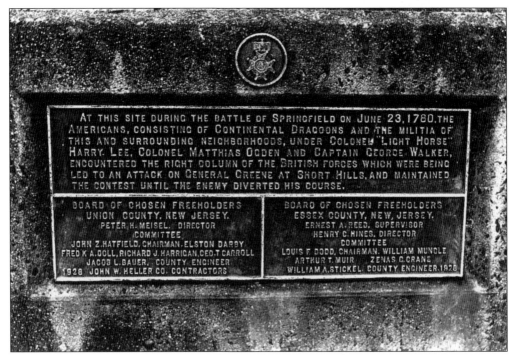

On June 23, 1780, Gen. Wilhelm Knyphausen decided to split his army into two sections in an effort to capture Gen. Nathanael Greene, commander of the Continental Army. The first section continued along the original route, the future Morris Avenue, while the second section turned off toward Vauxhall Road at the east branch of the Rahway River, where it engaged in battle with Col. Harry "Light Horse" Lee, Col. Matthias Ogden, and Capt. George Walker at Littell's Bridge. Observing the reflection of the sun on the weapons held by the men along the ridge, General Knyphausen feared the gap would become a death trap. He ordered his men to retreat and return to Staten Island.

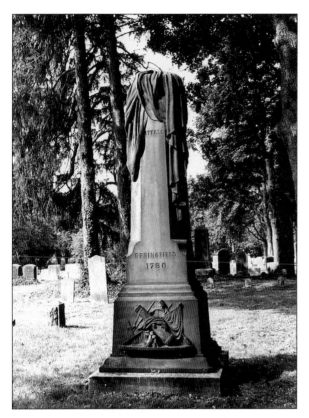

A 19th-century monument stands in the new Presbyterian cemetery for Capt. Eliakim Littell, who returned home to discover Hessian soldiers surrounding it and captured them. Considered to be one of Springfield's war heroes, he fought in more than a dozen engagements with the enemy. He was buried first in the Revolutionary War Cemetery and then moved to the new Presbyterian cemetery. The monument, with a short staff, is draped, indicating that his life was cut short.

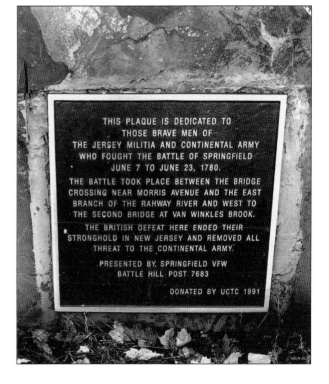

This plaque was dedicated in 1991 by the Battle Hill Post No. 7683, Veterans of Foreign Wars, in Springfield to replace an earlier plaque that was stolen. It notes that the battle occurred between Morris Avenue, the east branch of the Rahway River, and the Van Winkles Brook. It was the last major battle during the Revolutionary War in the North and ended Great Britain's presence in New Jersey. New York City, however, continued to be a British stronghold until Evacuation Day, November 25, 1783.

Col. Harry "Light Horse" Lee, hailing from Virginia, was the father of Civil War general Robert E. Lee, who led the Confederate Army.

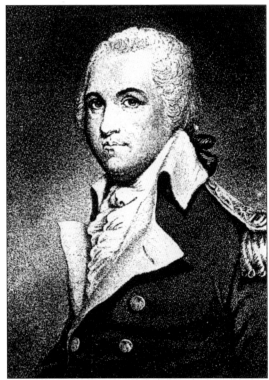

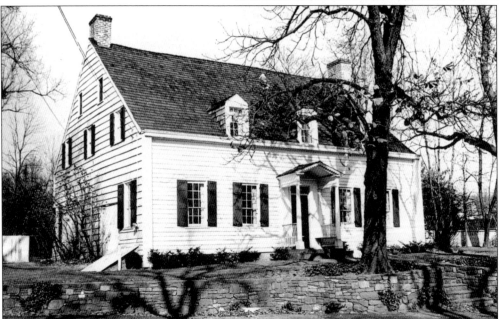

During the battle, two Hessian soldiers named Van Wert hid in an outbuilding at this house to escape capture. They settled in the community and became good American citizens. The house, still a private home, is known locally as "the Hessian House." It is located on Millburn Avenue in Millburn, then a part of the Spring Fields. Many of the mercenary soldiers deserted their units and stayed in the new nation.

This modern painting by Larry Felder for the Union Township Historical Society depicts Hannah Ogden Caldwell, her daughter Maria, and her husband, Rev. James Caldwell. Reverend Caldwell was pastor of the Presbyterian church in Elizabethtown from 1762 to 1776, when he joined the army as chaplain. The family moved into the parsonage of the Connecticut Farms Presbyterian Church. Hannah refused to leave the parsonage when she learned the British were approaching. She did not believe the soldiers would injure a lady. Unfortunately, Hannah Caldwell was wrong. According to testimony after her murder, the killer aimed at her as she sat in a back, first-floor bedroom holding one of her children. Her body was carried to a nearby house, and the parsonage was burned. The parsonage was rebuilt and became the property of the Union Township Historical Society in 1958.

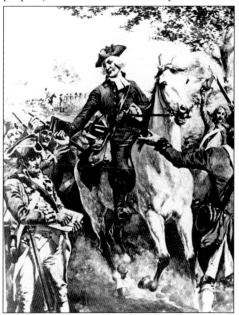

During the battle of Springfield, Rev. James Caldwell went to the Presbyterian church in the Spring Fields and got the hymnals by Isaac Watts. He distributed them to the soldiers, stating, "Give 'em Watts, boys. Give 'em Watts." The pages of the book were used for wadding in the rifles.

This photograph displays one such hymnal. The cannon balls were found after the battle by farmers in their fields.

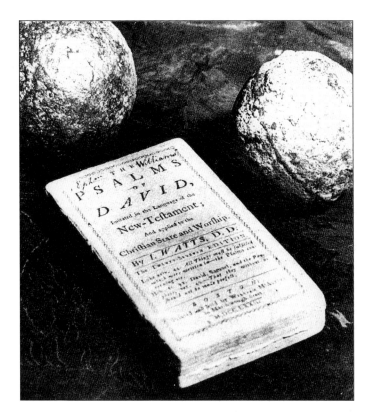

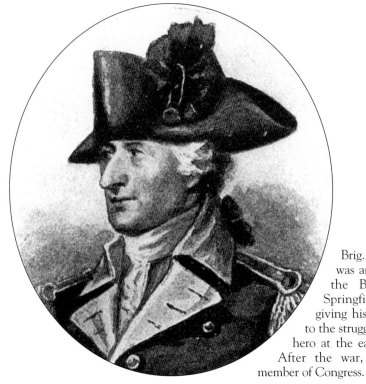

Brig. Gen. Philemon Dickinson was among the men who fought the British at the battle of Springfield. He was known for giving his fortune, time, and talents to the struggle for liberty. He was also a hero at the earlier battle of Monmouth. After the war, he became a Delaware member of Congress.

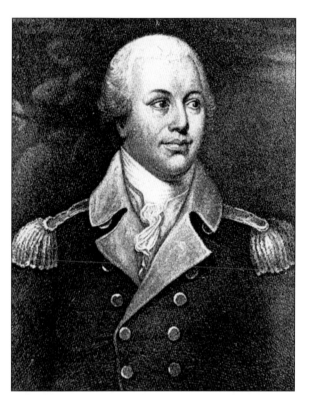

Gen. George Washington placed Gen. Nathanael Greene in charge of the Continental troops during the battle of Springfield. Greene watched and directed the army from the crest of First Mountain.

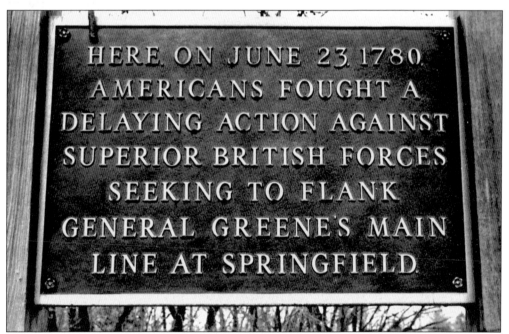

HERE, ON JUNE 23, 1780 AMERICANS FOUGHT A DELAYING ACTION AGAINST SUPERIOR BRITISH FORCES SEEKING TO FLANK GENERAL GREENE'S MAIN LINE AT SPRINGFIELD.

This plaque, standing on the border of Union and Millburn, states that the Continental Army fought a delaying action against superior forces on June 23, 1780, on Vauxhall Road at the bridge over the east branch of the Rahway River. Gen. Wilhelm Knyphausen faced Harry "Light Horse" Lee at the bridge. Overcome, Lee withdrew to the Short Hills behind him.

A six-foot-high granite monument in the Revolutionary War Cemetery was dedicated in 1896 by the New Jersey Sons of the American Revolution. The once three-acre cemetery has been radically reduced to a small house lot. The graves are decorated annually by the Daughters of the American Revolution.

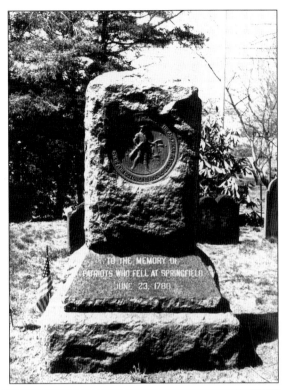

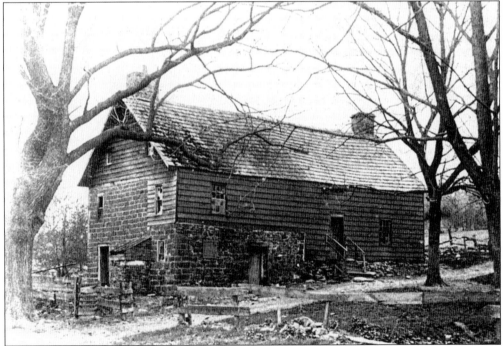

While stationed in New Jersey, Gen. George Washington was a guest at the Timothy Ball House in present-day Maplewood, then part of Springfield. Washington's mother was a member of the Ball family. The house has been restored and is a private residence today.

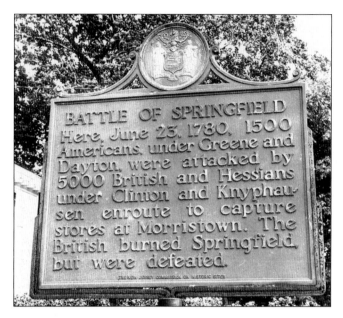

This sign marks the site of the battle of Springfield on June 23, 1780. It notes that a mere 1,500 Americans under Gen. Nathanael Greene and Col. Elias Dayton were attacked by 5,000 British and Hessian troops under General Clinton and General Knyphausen, who were attempting to capture Washington's supplies at Morristown. It adds that the British burned Springfield but were defeated. The Presbyterian church, used for storage of supplies for the Continental Army, was also burned.

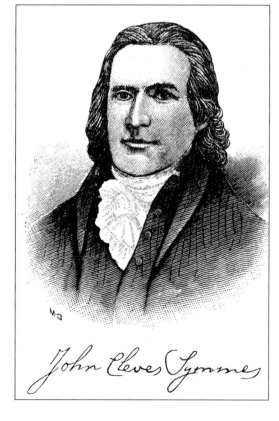

John Cleves Symmes—a land speculator and judge at the trial of James Morgan, the guard who shot and killed Rev. James Caldwell at the Elizabethpoint Ferry—was the son of Rev. Timothy Symmes, the first pastor of the Presbyterian church. John's daughter Anna is reported to have climbed out a window at Liberty Hall in Union Township to elope with William Henry Harrison, the ninth president of the United States.

The Cornelius Bryant House, on the north side of Morris Turnpike between Short Hills and Baltusrol Avenues, was photographed in 1963. Some historians claim that the house was standing during the Revolutionary War.

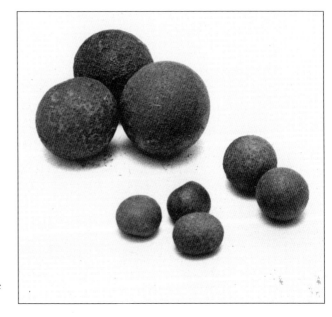

These variously sized cannon balls were found by farmers as they plowed their fields in the 19th century. They were apparently fired during the battle of Springfield on June 23, 1780.

This beacon was lighted in Bryant Park in June 1980, on the 200th anniversary of the battle of Springfield. Beacons like these were made during the Revolution to alert the patriots of attacks from the British. Two protected Springfield: the first on Beacon Hill on today's Hobart Avenue in Summit and the second in the South Mountain Reservation overlooking Millburn. Between 23 and 25 beacons were built on the mountains, where the patriots could watch the activities of the enemy on Staten Island and in New York City.

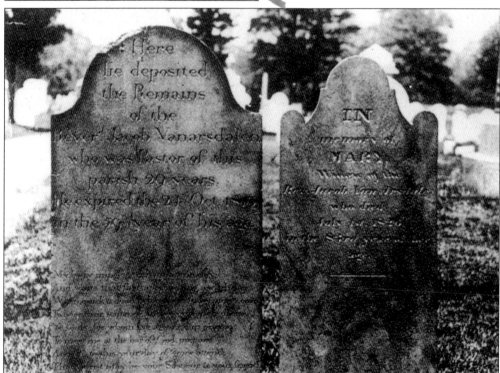

Rev. Jacob Van Arsdale, pastor of the Presbyterian church at the time of the Revolutionary War, is buried in this grave in the new Presbyterian cemetery. Sometimes his name is spelled "Van Arsdalen."

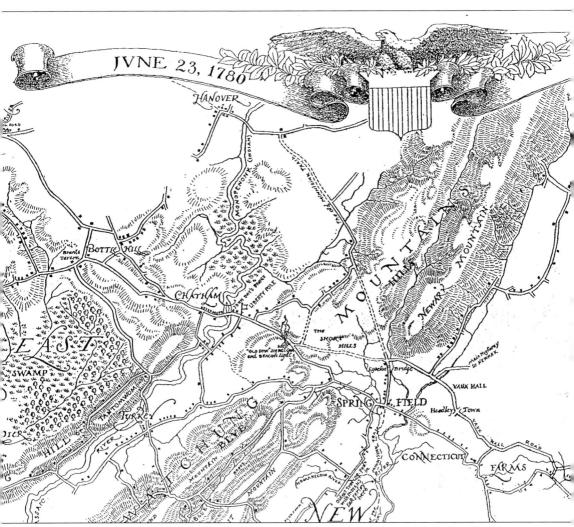

This map shows the site of the Spring Fields in front of the mountains that stretched from Middletown, Connecticut, into New York. The location of "Old Sow" is evident in the center of the map. While they were all part of the Watchung Mountains, various sections of land had local names as well, including the Newark Mountains and the Short Hills. At Day's Inn beside the Passaic River, the *New Jersey Journal* was started.

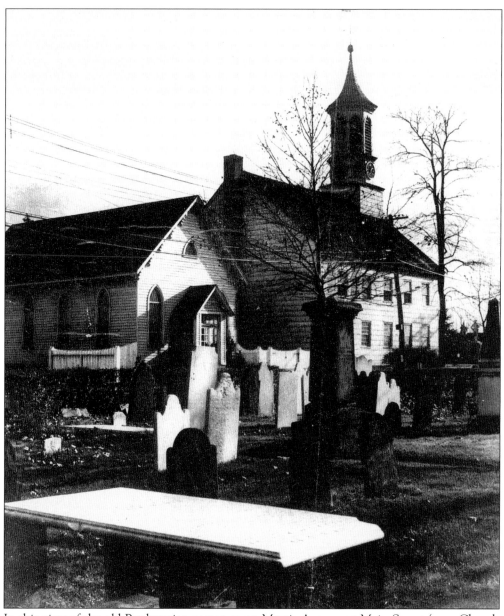

In this view of the old Presbyterian cemetery on Morris Avenue at Main Street (now Church Mall), the church and its chapel can be seen. The church is responsible for two cemeteries. In addition to this one, it maintains the new Presbyterian cemetery off Main Street.

# Three

# THE SPRING FIELDS
# BECOME A TOWNSHIP

By 1793, the people wanted their own government. They approached the state legislature, which adopted a law forming the township of Springfield. The people who were so eager to separate from Elizabethtown waited nearly a year before they held a referendum approving the law. The wait made Springfield the second instead of the first municipality to separate from Elizabethtown. The first was the West Fields, which became Westfield.

The 1794 township was much larger than the five-and-one-fifth-square-mile community it is today. It stretched from a portion of Livingston through South Orange, Maplewood, Millburn, Springfield, Summit, New Providence, and Berkeley Heights. Its western boundary went across the Passaic River into a small portion of Chatham. Gradually, the size of the township was reduced as New Providence borough was formed in 1809, New Providence township in 1899 (becoming Berkeley Heights township in 1952), and Summit in 1896. In 1857, Union County, the youngest county in New Jersey, separated from Essex County. Livingston, South Orange, Maplewood, and Millburn continued to be part of Essex. Today, Springfield is bordered by seven municipalities: Millburn, Union, Cranford, Kenilworth, Mountainside, Westfield, and Summit.

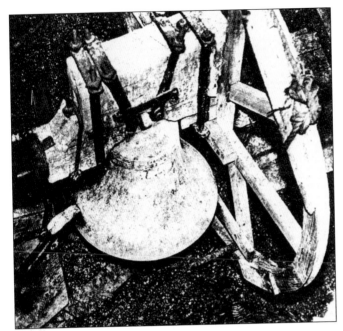

David Ross of Elizabethtown made this bell for the tower of the Presbyterian church in the Spring Fields before the Revolutionary War. After the war, Samuel Tyler gave the bell to the church, where it was placed in the new bell tower in 1792. A clock that had hung in the belfry was melted down, and a new one was made to replace it in the tower.

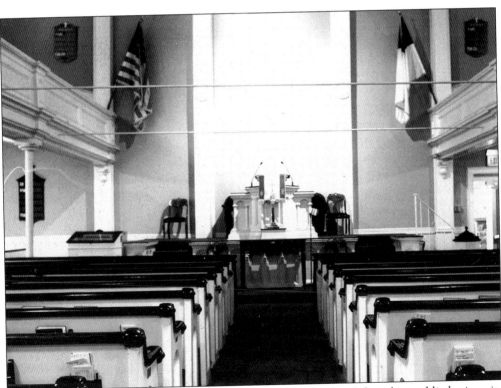

This is the interior of the Presbyterian church as it appears today. It has changed little since its reconstruction in 1791 to replace the original church burned by the British. Its foundation was restored and its walls reinforced in 1985.

This milestone stands in front of the Cannon Ball House on Morris Avenue. It gives the distance to Elizabeth as seven miles. Stones such as these were along many of the main roads in the 18th and 19th centuries to inform travelers about distances between places.

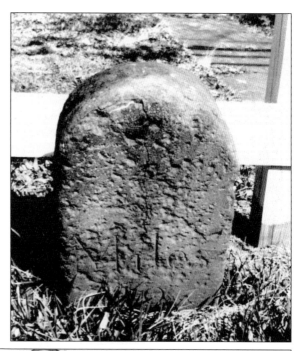

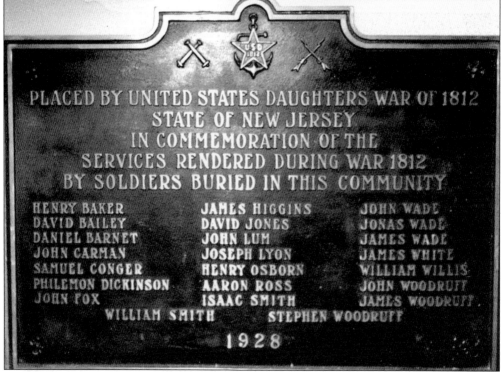

PLACED BY UNITED STATES DAUGHTERS WAR OF 1812
STATE OF NEW JERSEY
IN COMMEMORATION OF THE
SERVICES RENDERED DURING WAR 1812
BY SOLDIERS BURIED IN THIS COMMUNITY

| | | |
|---|---|---|
| HENRY BAKER | JAMES HIGGINS | JOHN WADE |
| DAVID BAILEY | DAVID JONES | JONAS WADE |
| DANIEL BARNET | JOHN LUM | JAMES WADE |
| JOHN CARMAN | JOSEPH LYON | JAMES WHITE |
| SAMUEL CONGER | HENRY OSBORN | WILLIAM WILLIS |
| PHILEMON DICKINSON | AARON ROSS | JOHN WOODRUFF |
| JOHN FOX | ISAAC SMITH | JAMES WOODRUFF |
| WILLIAM SMITH | | STEPHEN WOODRUFF |

1928

The War of 1812, the second war for independence, attracted 23 volunteers who were members of the Presbyterian church. No one was killed in battle since the war did not touch New Jersey; nevertheless, some of the men are buried in the old church cemetery nearby. The Daughters of the War of 1812 placed this plaque in the church to honor the volunteers for their service.

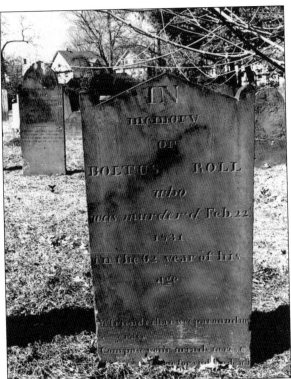

Baltus Roll, 61, who was dragged from his home during a robbery and murdered on February 22, 1831, is buried in this grave at the Revolutionary War Cemetery of the First Presbyterian Church in Westfield.

Baltus Roll was seized in this house on First Mountain, now sometimes called Baltusrol Mountain, and dragged out into the snow in his nightshirt. His frightened wife found the body and ran to a neighbor's house for help. Two men were arrested, tried, and convicted of the murder.

The Presbyterian Women's Association made this quilt on the 250th anniversary of the church's founding. The various patches depict highlights of history. It is on display in a church parlor.

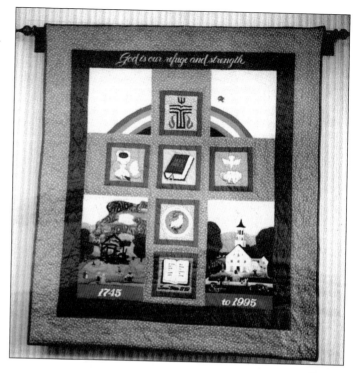

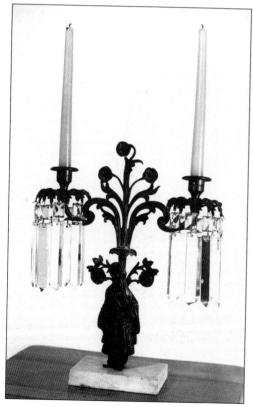

This candelabrum was a wedding gift to Jane Stites, who lived in a large house on the south side of Morris Avenue between Meisel and Linden Avenues. She was the mother of Louise Elmer and the daughter of William Stites, the grandson of the settler William Stites. Jane Stites married *c*. 1845. Note the unusual figure of a woman on the stem of the candelabrum.

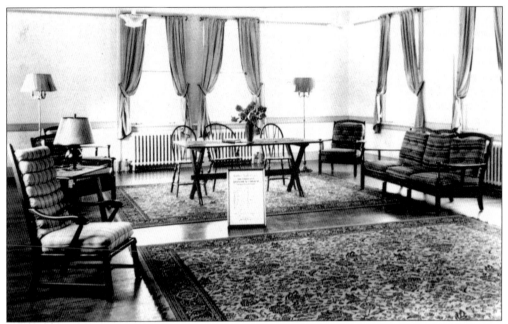

This photograph shows the Trivett Room in the Methodist Episcopal church, now the Springfield Emanuel United Methodist Church on Church Mall. It is named for the Trivett family, members for many years. The parlor was established when a three-story addition was added to the original church. It is used for meetings, classes, special occasions, and families during weddings and funerals.

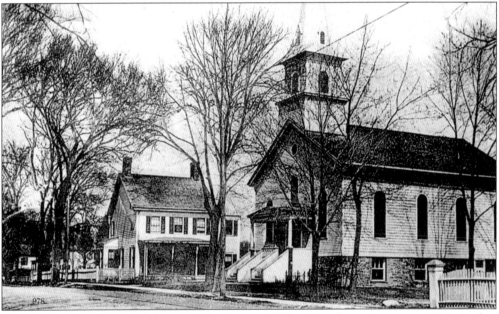

This is a view of the Springfield Methodist Episcopal Church and its parsonage c. 1896. At that time, the street was called Main Street. After Route 78 was built, it was renamed Church Mall. Formed in 1827, the church was built in 1833. A three-story addition was added in 1934, and renovations were completed in 1955.

Rev. W. A. Knox, pastor of the Springfield Methodist Episcopal Church from 1893 to 1898, raised sufficient funds to pay the church's mortgage. He also served as president of the Epworth League, a social and religious group, as did other clergymen at the time.

D. J. Mundy holds his daughter Freida while his son Charles leans against him. Mrs. Mundy stands at the right. Mundy was superintendent of the Sunday school at the Springfield Methodist Episcopal Church for 25 years.

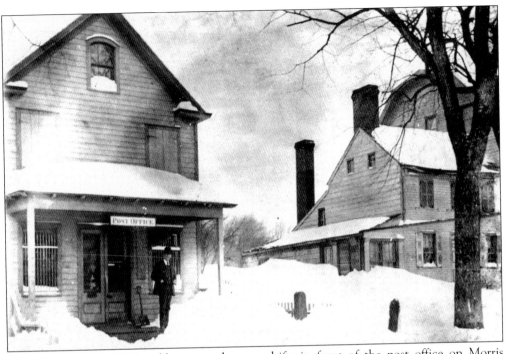

Postmaster George McDonald surveys the snowdrifts in front of the post office on Morris Avenue at Seven Bridges Road, or Bridge Road (Springfield Avenue), in February 1899. Until a post office was established, citizens picked up their mail at the local inn.

Every house and business was expected to have a bucket such as this with which to fight fires. When the church bell rang, signifying a fire, men would hurry to the scene of the fire and form a line to the nearest stream. Buckets were filled with water and passed down the line to be poured on the fire. The buckets were then returned to the stream to be refilled.

The original parsonage of the Presbyterian church was burned after the battle of Springfield. Rebuilt on its original foundation in 1844, it was used as a parsonage until 1964, when it was added to the new community building complex.

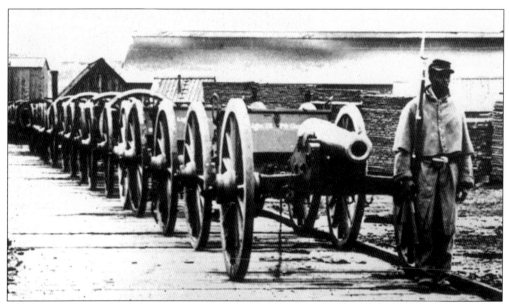

Civil War–era cannon are guarded by a Union soldier at an undisclosed location during the war. (Courtesy of the National Archives.)

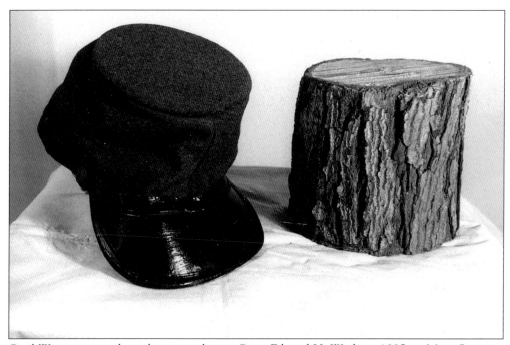

Civil War veterans planted a tree to honor Capt. Edward H. Wade in 1885 on Main Street at Academy Green. When the tree died, a piece of the trunk was saved and is currently displayed at the Cannon Ball House, along with an army cap worn by Wade.

William Clinton Poole joined Company B, 8th New Jersey Infantry, on August 19, 1864, during the Civil War. He died on December 20, 1906, and is buried in the new Presbyterian cemetery next to his brother Elias, a Confederate Army veteran.

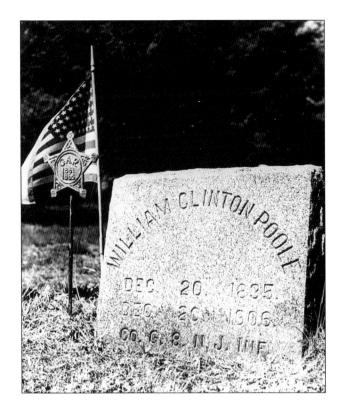

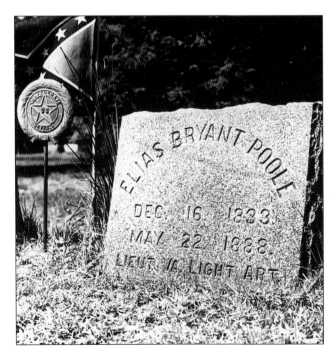

Lt. Elias Bryant Poole served in the light artillery in the Confederate Army. He was working in Virginia when the war broke out and enlisted. He returned home at war's end. Neither brother married, and they were buried side by side. For years Elias's stone was ignored on Memorial Day, while his brother's grave was decorated. Finally, in 1936, Herbert Day, a member of Spanish-American Legion Post No. 118, began putting carnations on his grave, too. Since then, the grave has also had a Confederate flag.

A multicolored dress hat worn by Capt. Edward H. Wade for formal occasions is included in the exhibit at the Cannon Ball House.

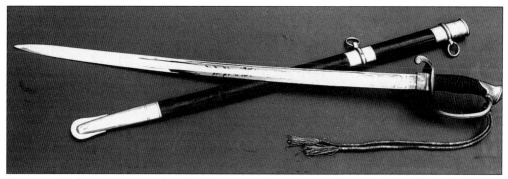

Captain Wade was presented with this sword by Company F, 59th New York Volunteer Infantry, on May 30, 1862. The sword and leather scabbard were intended for field use.

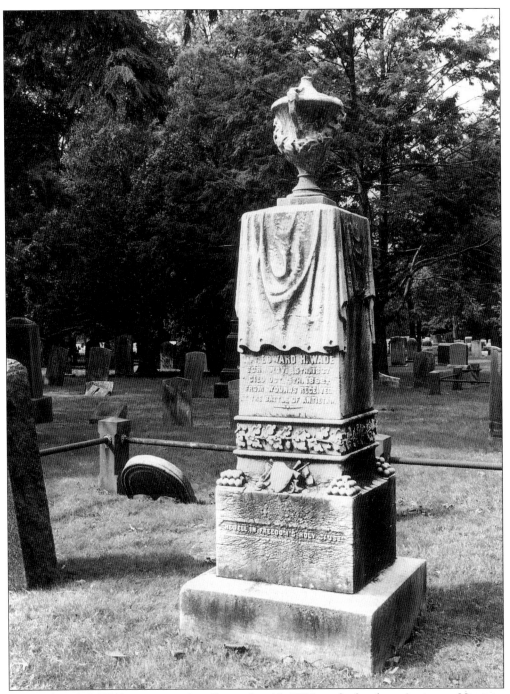

Capt. Edward H. Wade was injured on September 17, 1862, in the battle at Antietam, Virginia, and subsequently died on October 5. He was the only person from Springfield to be killed in the Civil War. Captain Wade's brother went to Virginia expecting to bring his wounded brother home. Instead, he returned to Springfield to bury him in the new Presbyterian cemetery. The monument appears to have been cut short and draped with cloth. Both are symbols of a life clipped.

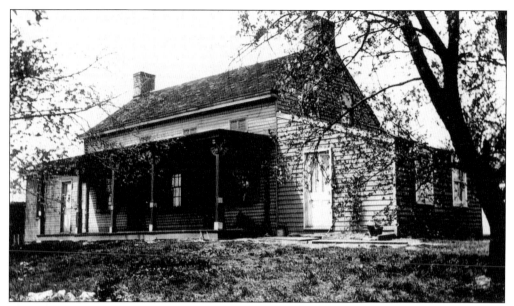

This wood-framed house was erected in 1819 by Abraham Roll for his son Isaac, who married Catherine Van Dyke in 1821. Note the two chimneys—one at either end of the house—for two fireplaces. The dwelling has lie-on-the-stomach windows, a shed-like lean-to on the right, and a front porch.

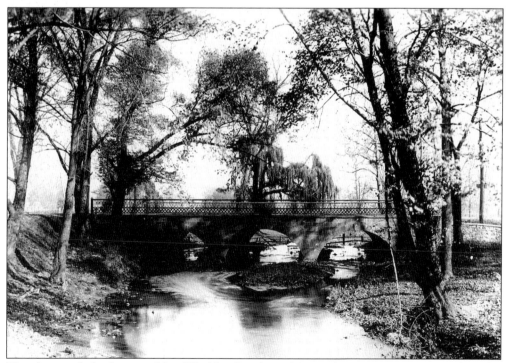

The three-arch bridge over Van Winkles Brook on Morris Avenue was constructed in the 1870s and continues to support Morris Avenue today.

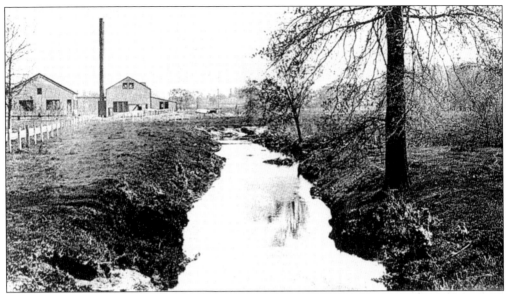

These waterworks, a portion of the Rahway River, were featured on an early-20th-century postcard. The water, necessary to power mills, was also used for drinking until wells were dug or springs found. Much of Springfield is in a flood-prone area due to the river and its tributaries.

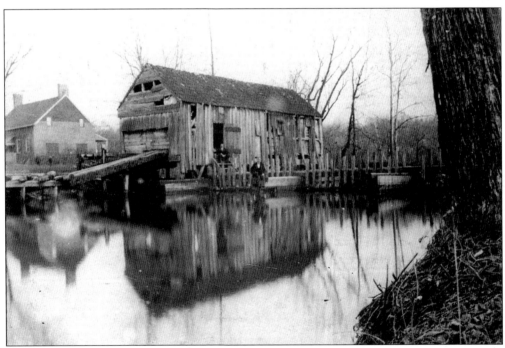

A section of Springfield and Union was known as Milltown because of the two mills powered by the Rahway River. Pasteboard was made in the Springfield mill. This view, however, shows the Union sawmill. J. Edgar Meeker was the mills' last owner. Eldorado Park was located on the site briefly. Flooding was caused by a dam placed across the river to create a lake. After the township committee ordered the dam removed, Eldorado disappeared. The land is part of the Rahway River Park, a Union County park.

Tintypes of children were taken in the period after the Civil War and before 1890. These four c. 1895 tintypes are in the collection of the Springfield Historical Society. Florence Terry is dressed in a fancy, long dress for her baptism, or christening. Both boys and girls wore long dresses for these rituals in infancy.

Annie Lushear sits beside three books in this tintype, presented to the Springfield Historical Society by Mrs. Thomas W. Matthew of Nixon on January 28, 1960. Donald B. Palmer, a local historian, received the photograph, one of the oldest in the society's collection.

Brothers Benjamin (left) and William N. Heard pose for a photograph in a studio. William inherited the Cannon Ball House.

Benjamin (left) and William N. Heard wear Peter Pan collars for this formal portrait with the family dog, their mother, Ida (seated), and two nannies. The Heards resided in the Cannon Ball House for many years. When they lived there, it was called the Hutchings homestead, after a former owner.

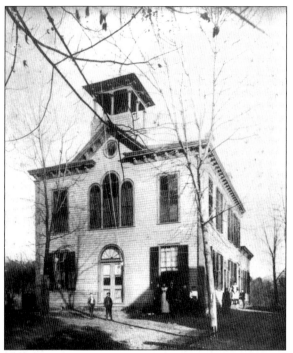

The Union Academy on Main Street served as the municipal building from 1858 to 1901, when it burned. An earlier school, the Springfield Union Academy, was organized in 1802 and was built on Academy Green between Main Street and Black's Lane. When the Springfield Union Academy burned in 1856, the Methodist church provided its basement for classes.

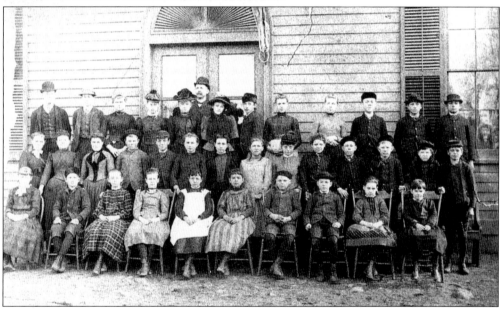

Students at the Union Academy pose *c.* 1900 with the principal and teachers. From left to right are the following: (first row) Nettie Quinzel, Frank Meisel, Louise Graves, Susan Howard, Hannah Compton, Bessie Robinson, Doris Squiers, Albert Cain, Elfreda Hagel, and Mary Cain; (second row) Hattie Cain, Lillie Woodruff, Nellie Wilcox, Elmer Wilcox, Charles Stearns, Mary Schramm, Josie Hage, Ellie Diener, Sadie Clark, Ida Howard, Richard Corby, Clarence Barber, Louise Sprague, and A. Trengove; (third row) Oliver Collins, Herbert Higgins, Florence Diener, Anna Parse, May Jackson, W. L. Sprague, Edna Terry, Melvin Carter, Lulu Howard, Sadie Squiers, Olin Sickley, Elmer Day, and Charles Robinson.

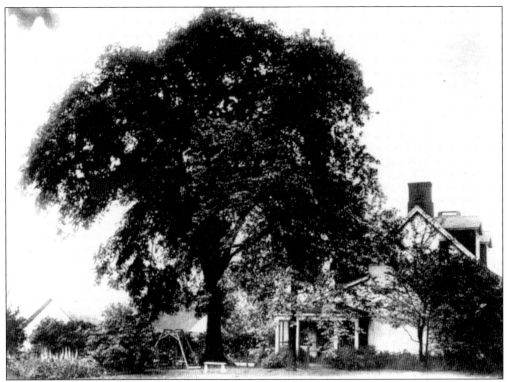

A huge elm tree shades a house in Springfield. Before the Dutch elm disease destroyed the trees, they were numerous throughout Springfield.

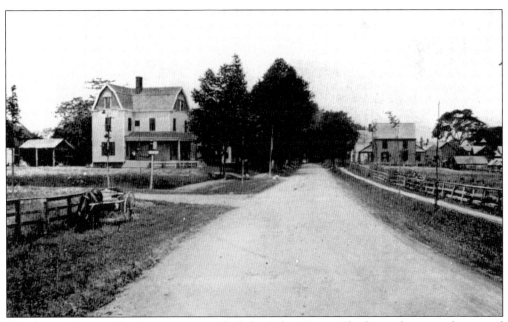

The first real estate development was called the Salter Tract. The house lots were large, and the roads in front of the dwellings ran straight and wide. The house at the left is one of the first houses in the tract. A farm appears on the right side of the photograph.

Peter Meisel was the first developer of the Salter Tract in Springfield. Most of the houses were two-and-a-half stories high with open porches. Here, two people sit on the front porch. Front porches were especially popular during the late 19th and early 20th centuries.

# *Four*

# FROM FARMS TO FLOWERS

The F and F Nursery was one of the first and largest nurseries in Springfield. Numerous chicken farms, such as Gage's, populated the town, as well as truck farms and apple orchards. In addition, there were farms specializing in single crops such as pansies, and at least two farm stands stood on South Springfield Avenue: Prince's and Sam's. The first proposed developer was Capt. W. T. McJilton in 1873, a Confederate Army officer who purchased a large tract of land and subdivided it into streets but did not build. One of the street names that has survived is Wabeno Avenue. Construction had to wait until Peter Meisel began work on the Salter Tract in the late 19th and early 20th centuries. The initial lots were large and the houses spacious.

At this time, little industry thrived. The American Chemical Company occupied the area later known as Dayton High School's Meisel Field, and the Celluloid Zapon Company had a factory on Morris Avenue above the center of the hamlet. The Union County parks department acquired parcels of the Meisel Field land in 1927 and in 1930. A portion of Lenape Park, a county park, is also located in Springfield.

The building for the F and F Nursery appeared to be a castle. The huge barn at the left was an extension to the original building at the right. The nursery became the General Greene Shopping Center on Morris Avenue, and the property was extended to the Jonathan Dayton High School.

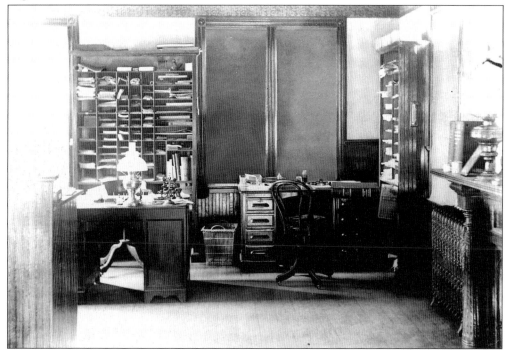

The F and F Nursery used this room as its office. The nursery records are stored on the shelving behind the large desk. Note the oil lamp on the desk. Springfield was served with electricity c. 1905.

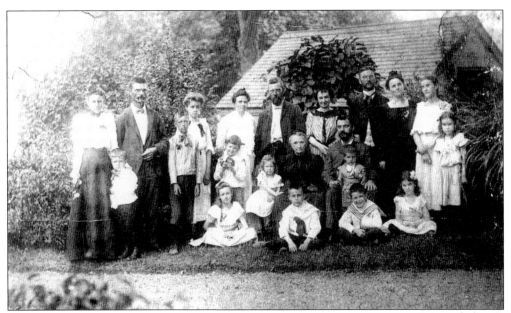

The Flemer family and guests pose for a photograph in 1898. Starting fourth from the left, those identified are Carl Flemer, Helen Flemer, Mrs. Flemer, and William Flemer Jr. (in front of Mrs. Flemer). Seated are Martha and William Flemer Sr.

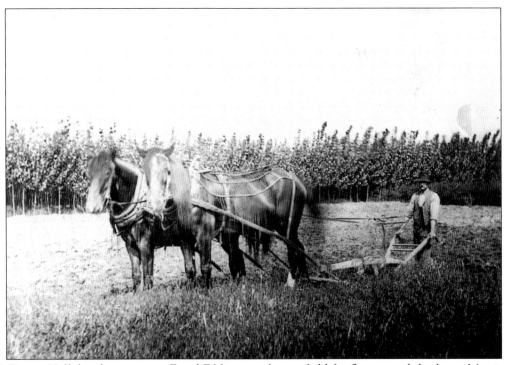

George Hall, head teamster at F and F Nursery, plows a field for flowers and shrubs on Morris Avenue, along with horses Dick and Ben. Note the grove of nursery trees behind him.

A single house has been completed on Keeler Street on the Salter Tract. A sign at the right advertises the project.

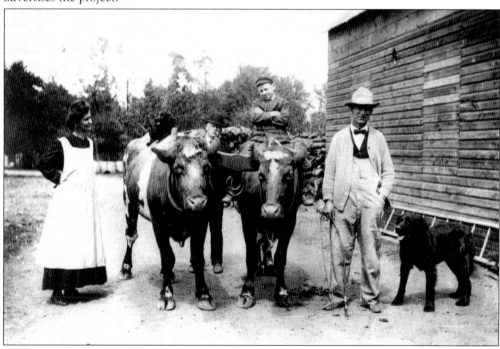

Claudius, or Claude L., Baker drives the last team of oxen in Springfield. Baker had a farm on the southeast corner of Westfield Avenue (now Mountain Avenue) at Shunpike Road, where he operated a milk and cream business. He usually used the oxen to plow his fields, but sometimes he had them pull the wagon when he delivered milk. Some residents believed the oxen were a publicity stunt. Shunpike Road was developed when the turnpikes were built. People went around the pikes at the tolls to avoid paying them; this was called "shunning the pike." Thus, the roads they took became known as shunpikes.

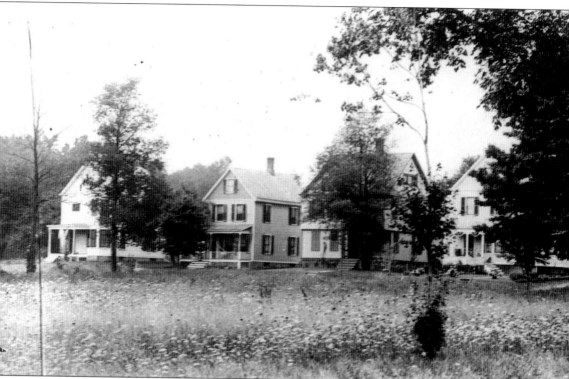

The first successful real estate development in Springfield was in 1893, when Jasper C. Salter purchased land for the Salter Tract. The area included Keeler Street, Salter Street, and Bryant Avenue. The first dwellings along Salter Street erected that year were for William C. Davis, J. Pettinger, builder Peter Meisel, and John I. Denman, whose homes are shown here from left to right. This photograph was taken by E. D. Pannell, an employee at the F and F Nursery.

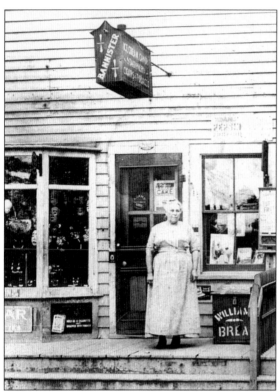

The Bannister Store was one of the stores in Springfield in 1900. A woman believed to be Mrs. Bannister stands in front of the door. Note that the store has a porch with at least two steps and a railing. The sign in the storefront offers bread and cigarettes for sale.

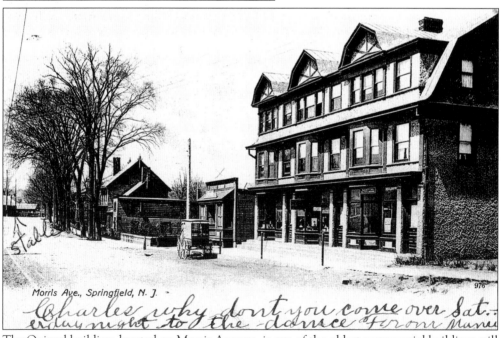

The Quinzel building, located on Morris Avenue, is one of the oldest commercial buildings still standing in Springfield and one of the most unusual. Stores are on the ground floor, and apartments sit above them. The stores include the Jeakens Store, Neuman Grocery Store, and Garabrant Drug Store. The bridge over Van Winkles Brook may be observed behind the wagon.

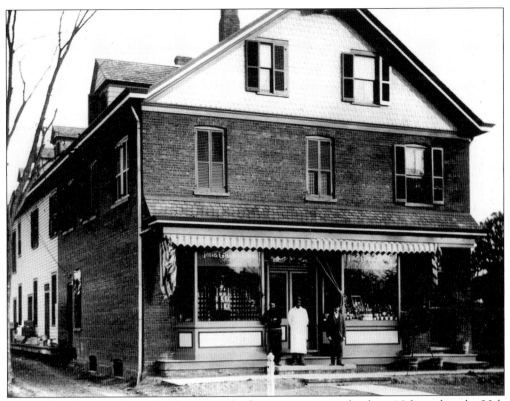

Gantzsell's Store in Springfield is typical of many stores in the late 19th and early 20th centuries. The basement or first floor of a dwelling was turned into a store, while the family lived behind or above it.

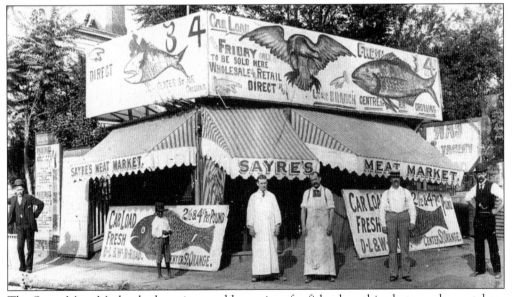

The Sayre Meat Market had awnings and huge signs for fish when this photograph was taken. The fish were said to be "direct from the sea," and the meats included beef, lamb, and pork. The food was sold both retail and wholesale.

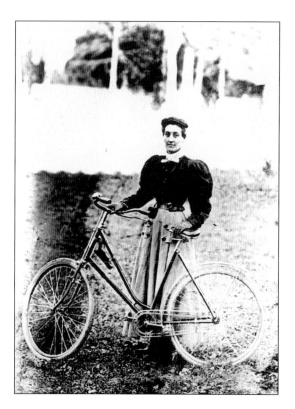

Anna A. Sheville, who became Mrs. David S. Jeakens, poses for the photographer before taking a bicycle ride c. 1896.

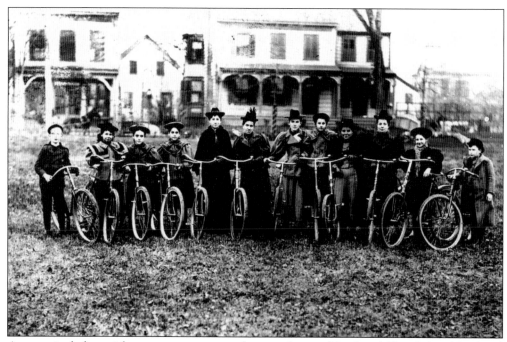

A group including eight women, two young boys, and twins Hazel and Elsie Leber (third and fourth from the left, respectively) prepares to take a bicycle ride in 1898. Bicycle clubs and groups are said to have lobbied for better and safer roads for riding.

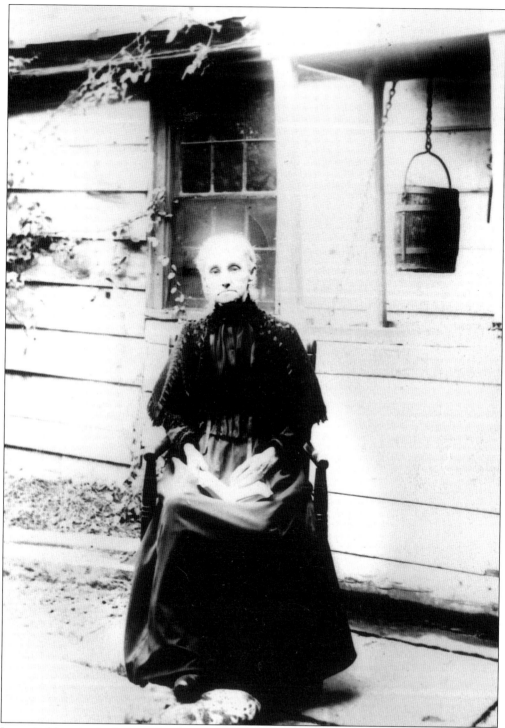

Lucy Sickley sits in front of her home. Note the wooden bucket hanging behind her. Such buckets were used to draw water from many wells in the township.

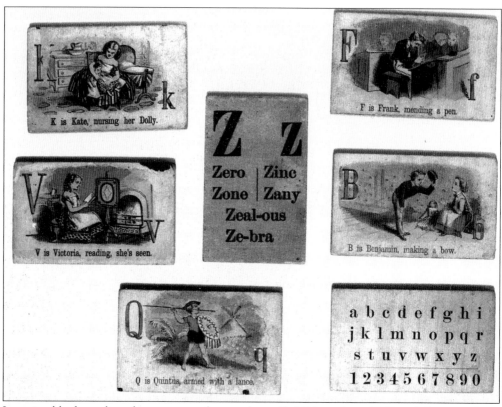

Learning blocks such as these were used to teach small children their ABCs and their numbers. The colorful blocks were illustrated with objects using the respective letters. Such blocks may be viewed at the Cannon Ball House, operated by the Springfield Historical Society.

Posing for a photograph was a serious experience for Joseph Semmel (right) and his sister. Note the large, popular hair bow on the little girl's head. All boys at the time wore knickers, for trousers were a sign of maturity. It was unusual for even a little boy to pose for the photographer without wearing his suit jacket.

Three children, dressed in their winter clothes, pose for the camera in 1888. Pictured here, from left to right, are Edna Townley Terry, Walter Jobs, and Edith Bailey Denman Willis. Edith carries a muff, a very popular fashion statement early in the 20th century.

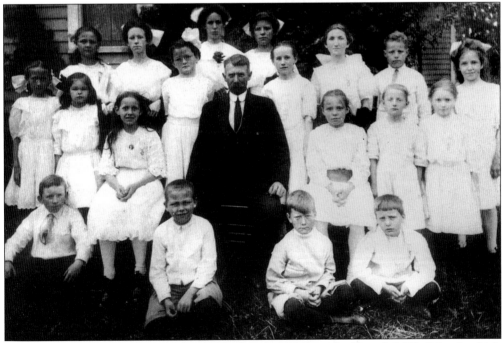

Children surround Charles French, principal and teacher at the Branch Mills School, which served part of Westfield (now Mountainside) and Springfield until 1913, when the Springfield children began attending the James Caldwell School. The children were taken to the Caldwell School by sleigh or horse and wagon. The number of children in the Branch Mills School ranged from 27 to 38. Children attended school from October to April; the rest of the year, they were busy helping on their families' farms.

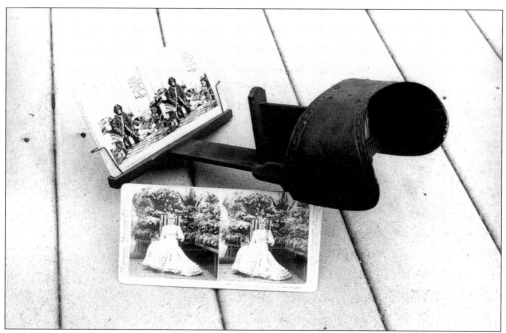

Stereoscopes were very popular at the time. Nearly every home had the instrument on a table, along with two identical photographs. When viewed through the lens, the photographs became three-dimensional.

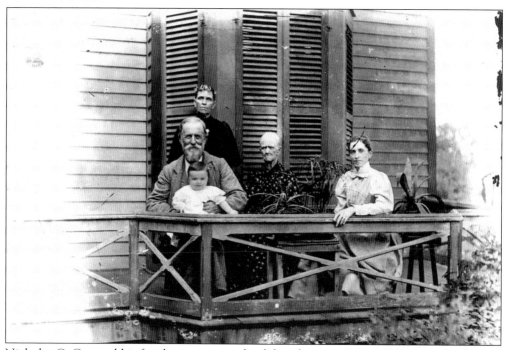

Nicholas C. Cox and his family sit on a porch of their home in June 1898. Note the shutters on the bay window behind them. Beards were popular among gentlemen. The women wore high-necked dresses, even on hot summer days, and babies were often clothed in long dresses and high shoes.

Ida Heard resided in the Cannon Ball House from 1896 until her death in the 1930s. She willed the house to her son William, who sold it to Celia and Gloria F. Silke shortly after the end of World War II. In 1924, Ida built a cellar so that a central heating system could be installed. During this repair work, a cannonball apparently fired by Continental troops on June 23, 1780, was found embedded in the western wall, giving the house its name.

Noah Raby was buried in the Luther Denman plot in the Presbyterian cemetery after his death on March 1, 1904, at 131 years and 11 months of age. Born in Gates Courthouse, North Carolina, on April 1, 1772, he was the son of a Cherokee Indian and a Caucasian woman. He served with the navy during the War of 1812 and worked on farms for the rest of his life. Raby was featured in a story by ABC News about people who lived through the entire 19th century.

Rev. William Hoppaugh served as pastor of the Presbyterian church from 1887 to 1913, when he retired. Unlike other pastors, he returned to Springfield to serve as the municipal tax collector, treasurer, and clerk of the board of education until his death in 1930.

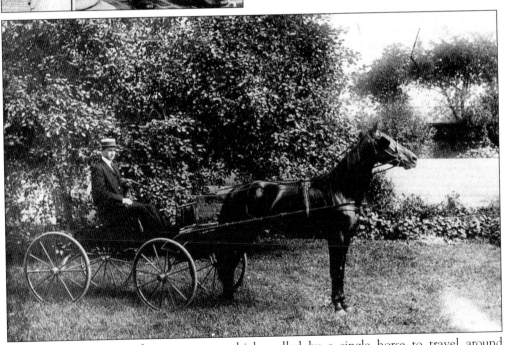

Benjamin Heard Jr. used a two-seater vehicle pulled by a single horse to travel around Springfield on pleasant days. Note the straw hat he wears; such hats were very popular from 1900 to 1930. Horse-drawn vehicles disappeared from the streets in the 1920s.

Lucy Van Fleet pauses to have her photograph taken in Springfield. She holds a black umbrella, which she can use to protect herself from the rain or sun. Most women wore hats when they went out of their homes c. 1896. This is a Pannell photograph from the Donald Palmer Collection at the Springfield Public Library.

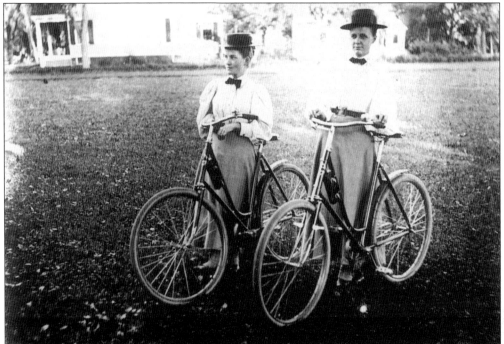

Bicycle riding was very popular in 1896. In this photograph, taken by Pannell and now part of the Donald Palmer Collection, Maria (left) and Jessie Bloy wear long skirts and white blouses with little bow ties and hats.

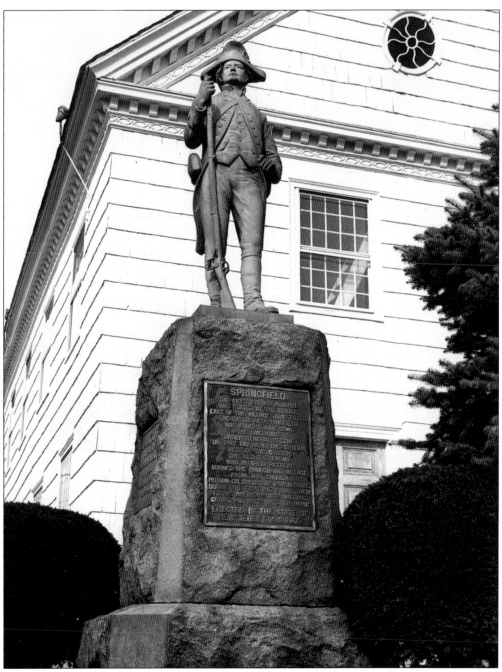

The statue of the Continental soldier in front of the First Presbyterian Church in Springfield was dedicated by the state of New Jersey on June 23, 1905, the 125th anniversary of the battle of Springfield. The soldier is in full uniform with a tricorn hat. He is holding his musket. The statue stands on the state's smallest park, just five by five feet.

*Five*

# TRANSPORTATION CHANGES

The invention of motorized vehicles changed American life. Automobiles, motorized buses, and trucks made places more accessible and supplied food and fruit from great distances. Before 1903, when several favorite cars were introduced, people either walked, used horse-drawn vehicles, or rode trains. Few people went more than 10 miles from home. The motor-powered vehicles opened the nation to the people, as records for time and distances were made and broken.

The improved roads and methods of transportation enabled people to move out of the cities into the surrounding hamlets for a better life. Charming cottages and mansions were built. Buses and trains provided a faster and easier method of reaching the cities for work, play, and goods. Cow pastures, plant nurseries, and chicken farms gave way to residences and light manufacturing and commercial businesses. Real estate advertisements estimated the amount of time it would take a resident to reach the cities. The world was opening up.

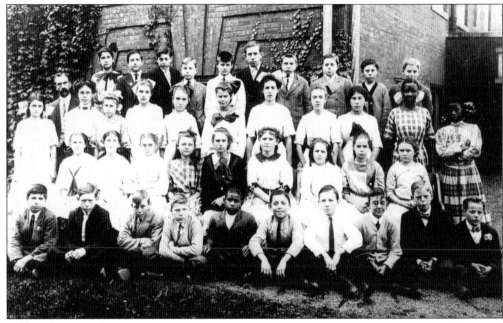

The sixth-grade class at the James Caldwell School sits for the photographer in 1913. Until 1922, when the Raymond Chisholm School was built, it was the only school in the township.

The James Caldwell School, built in 1901, is named for the pastor who distributed hymnals during the battle of Springfield. The third floor contained the administration offices and high school. The third floor was removed when students were sent out of the township for high school. Additions were built in 1925 and 1936. The James Caldwell School replaced the Union Academy, which burned.

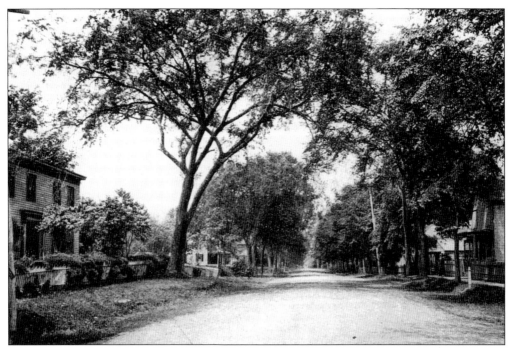

This *c.* 1893 view looks from the Springfield post office up Morris Avenue toward Short Hills in Millburn. Note the trees and the houses lining the street.

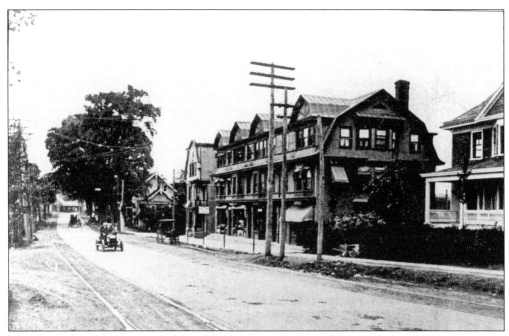

The Quinzel building is one of the oldest multipurpose buildings in the township. This 1903 view was taken shortly after automobiles appeared. Note the dwellings adjacent to the building. These disappeared as the section became Springfield's downtown. Route 78 is located where these trees once grew.

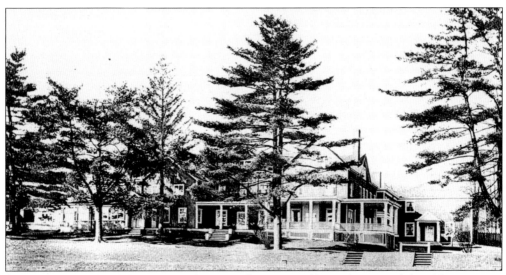

The Baltusrol Golf Club was formed in 1895 by Louis Keller and is one of the oldest country clubs in the nation. The country club now has two 18-hole courses. For a time, there was only one 9-hole course. An 18-hole course was then added, and the 9-hole was extended. The former was designed by golf architect A. W. Tillinghast. A farmhouse served as the first clubhouse.

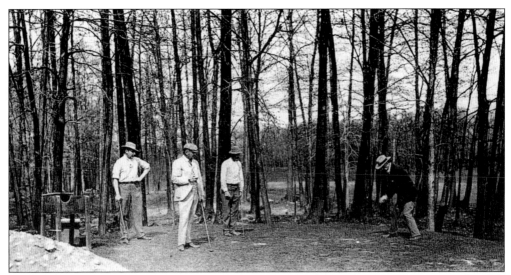

A foursome plays a game of golf at the Baltusrol Golf Club in 1905. For many years, the club gave its address as Short Hills, a section of Millburn. After a protest by the Springfield Township Committee, the club began to say it was located in Springfield.

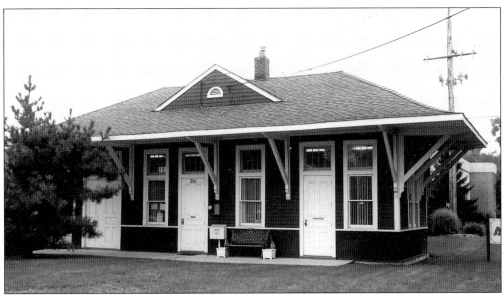

Only one of the two stations for the Rahway Valley Railroad in Springfield still stands on Mountain Avenue: the Baltusrol Station. The other station was at the golf course. The old New York and New Orange Railroad from Aldene on the Central Railroad of New Jersey was started in 1895 and sold to Louis Keller's new Rahway Valley Railroad in 1904 to carry Keller's friends from New York City to the golf club. Keller was the owner of the *New York Social Register*. The remaining station is now a print shop.

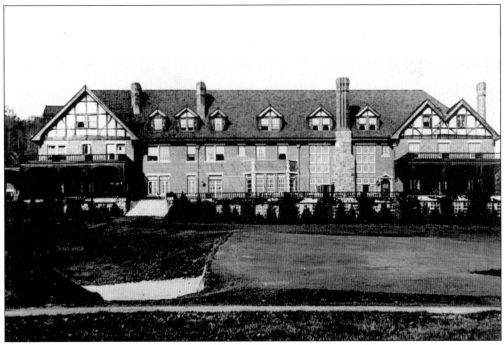

The original clubhouse of the Baltusrol Golf Club was destroyed by fire on March 27, 1909. It was replaced in 1911 with this beautiful building featuring two dining rooms.

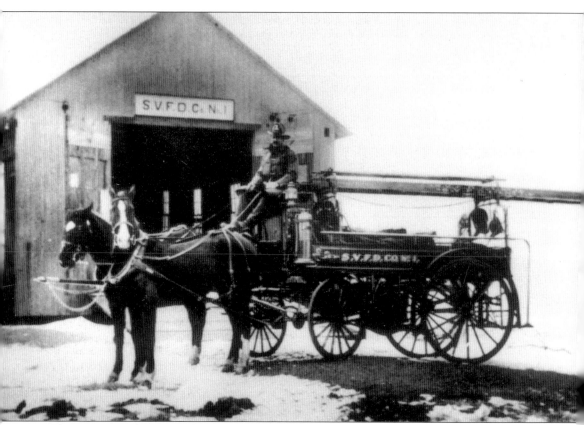

This wagon, made in 1910 by Joseph Koch, was the first piece of equipment for the Springfield Volunteer Fire Department. The wagon was pulled by two horses supplied by volunteers when needed and was kept at 295 Morris Avenue. Volunteers were called to fires by the ringing of a gong. Charles H. Ruby appears in the driver's seat in this photograph.

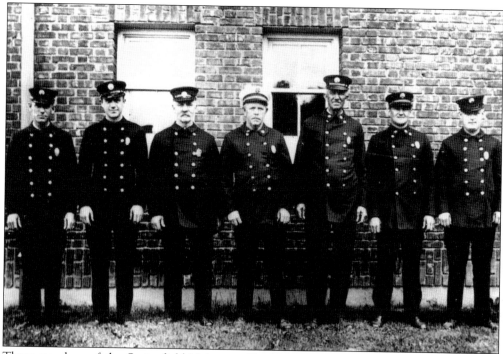

These members of the Springfield Volunteer Fire Department were active volunteers in the company and in township activities between 1925 and 1930. They include, from left to right, Reuben M. Marsh, Cecil Jeakens, former chief David S. Jeakens, Chief George Sisco, former chief Edward H. Ruby, future chief Charles A. Pinkava, and George Parsell.

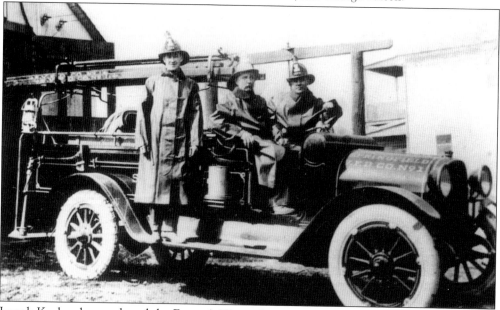

Joseph Koch, who purchased the Farrow's Wagon business, made the first motorized vehicle for the Springfield Volunteer Fire Department in 1917. It included part of an old wagon and a Reo automobile body chassis. Koch donated his work to the volunteers. The men with the machine, from left to right, are Delmar A. Tappan, Edward Ruban, and Joseph Pinkava.

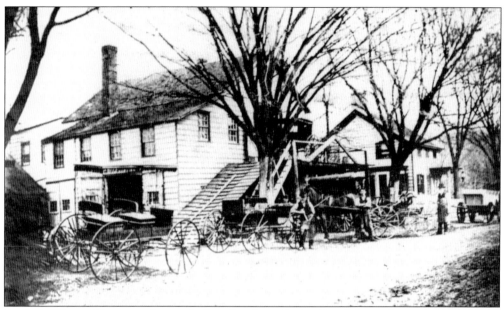

Farrow's Wagon Shop, on Seven Bridges Road, or Bridge Road (now Springfield Avenue), repaired carriages and wagons in a two-story building. A ramp at the right side of the building was used to pull them to the second floor, where the paint shop was located. A blacksmith shop was on the first floor. Standing in front of the vehicles, from left to right, are James W. Farrow, John Bagder, and George W. Cain.

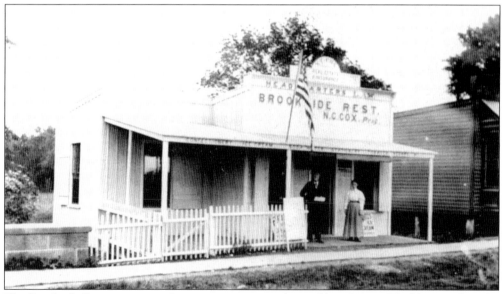

The Brookside Restaurant, in a former ice cream stand, stood beside Van Winkles Brook at the turn of the century. It was operated by Nicholas C. Cox and his wife, who are seen here in front of the establishment. The couple lost their home when the academy burned in 1901, destroying the school and headquarters of the township, as well as houses.

James W. Farrow was the proprietor of Farrow's Wagon Shop on Seven Bridges Road, or Bridge Road (now Springfield Avenue). Farrow was the treasurer of the board of trustees of the Presbyterian church from 1889 to 1906, when he died. An elder in the church, he was also active in the Sunday school. He was a member of the township committee from 1871 to 1873.

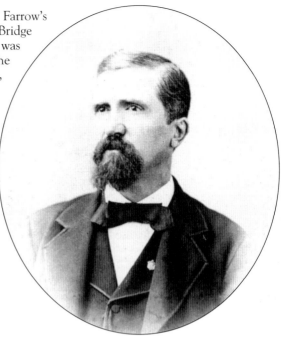

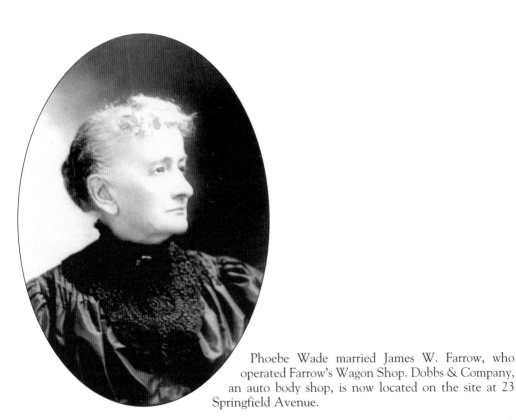

Phoebe Wade married James W. Farrow, who operated Farrow's Wagon Shop. Dobbs & Company, an auto body shop, is now located on the site at 23 Springfield Avenue.

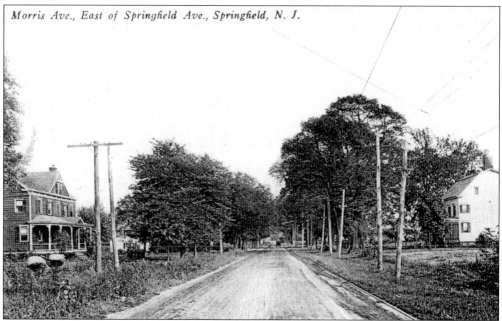

*Morris Ave., East of Springfield Ave., Springfield, N. J.*

This *c.* 1906 postcard view of Morris Avenue east of Springfield Avenue shows that electricity has been introduced. The few houses along the street are set wide apart and well back from the road.

Several small hotels were opened in Springfield in the 19th century. The Springfield Hotel was apparently built after 1800, because it was used as a stagecoach stop on the new Morris Turnpike. It stood on Morris Avenue opposite present-day Caldwell Place at Duffy's Corner. This photograph was taken in 1897, when the township committee and other municipal meetings were conducted in the hotel. The building was razed in 1930. Note the second-floor porch and four chimneys.

This old building on Baltusrol Way was called a "roadhouse" by the *Newark Evening News* in 1934. Roadhouses were usually places where liquor was sold during Prohibition, from 1920 to 1933. When Franklin D. Roosevelt became president, Prohibition was repealed. It was an unsuccessful effort to prevent the drinking of alcoholic beverages.

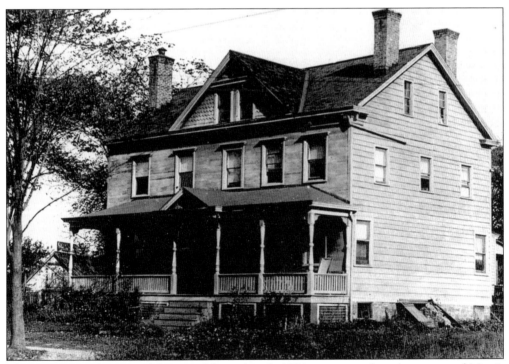

The Lower Hotel, pictured here on November 1, 1924, once stood at the corner of Morris Avenue and Seven Bridges Road (now Springfield Avenue).

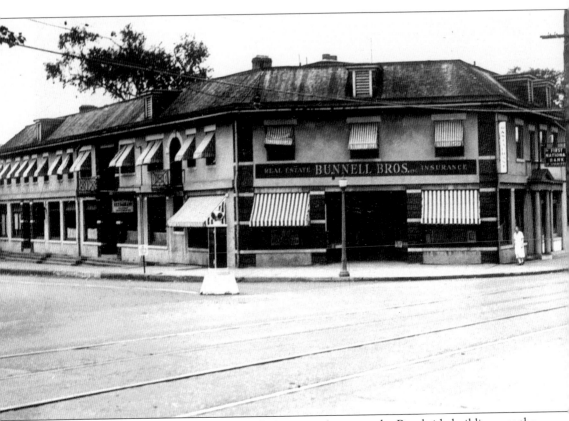

Erected c. 1915 at the corner of Morris and Mountain Avenues, the Brookside building was the office of the First National Bank of Springfield when it opened on October 5, 1925. It became the Springfield branch of the National State Bank on June 14, 1956. Robert S. Bunnell's office was next to the bank. Springfield's first library was in a storefront in the building, and the popular Kree Mee Fudge Company occupied the second floor.

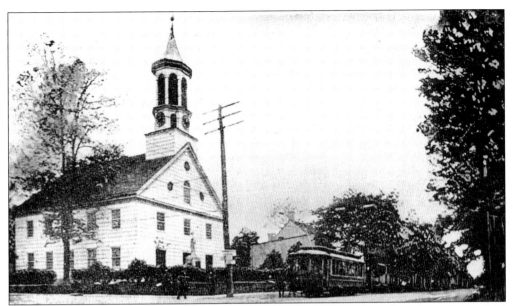

The Morris County Traction Company had begun trolley service from Summit to Springfield by 1904. At first, the cars were pulled along the tracks by horses. The horses were soon replaced by electric wires placed on both sides of the tracks. Gradually, the tracks were extended along Morris Avenue to Elizabeth and along Seven Bridges Road (now Springfield Avenue) to Newark. Here, the crew of a trolley car poses by the Presbyterian church after the Continental Statue was unveiled.

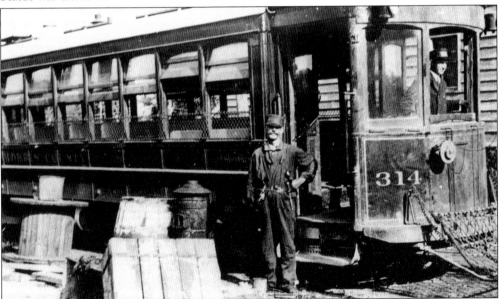

The Morris County Traction Company also operated trolleys between Summit and Maplewood. In this 1918 photograph, the conductor is outside the trolley and a motorman is inside. The tracks were moved from the sides of Morris Avenue to the center of the road. Residents protested that the tracks made it easier to skid, and they were soon covered with concrete. Buses began replacing trolleys; however, during World War II, trolley buses were used to save gasoline for the war effort.

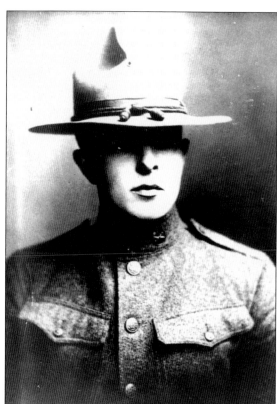

Raymond Chisholm, killed in battle in 1918 during World War I, was buried in Arlington National Cemetery in 1921. He was the only resident to be killed in that war's combat. Four others died from other causes. Springfield's second public school is named for Chisholm.

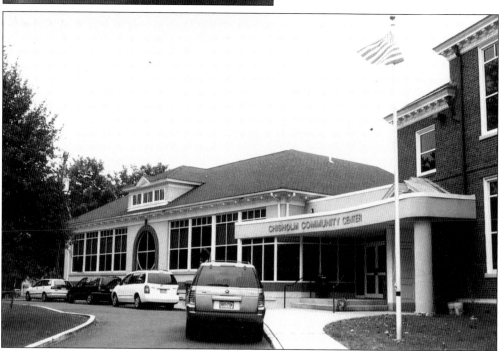

The Raymond Chisholm School was built in 1922. It is now the Raymond Chisholm Community Center, used by the Springfield YMCA.

# Six

# THE 1920S
## THROUGH THE 1960S

The years between World Wars I and II and those that followed were busy times for Union County, and Springfield was one of the busiest places. In 1920, the population was 1,715 and grew to 3,725 by 1930, as developers began to subdivide more farms and Route 22 was cut through the easterly portion of the township. Springfield made educational history when the first regional high school in the state was built there. After years of depending upon constables and volunteers for law enforcement, a police department was formed in 1928.

Pictured from left to right, Carrie Flemer and Maude, Helen, and Florence Terry enjoy the prospects of a ride in an open touring car *c.* 1916. Cars at that time were closed by covers that snapped into place. They were delightful on warm days, but their lack of heat and air conditioning made them uncomfortable on cold days and hot summer days.

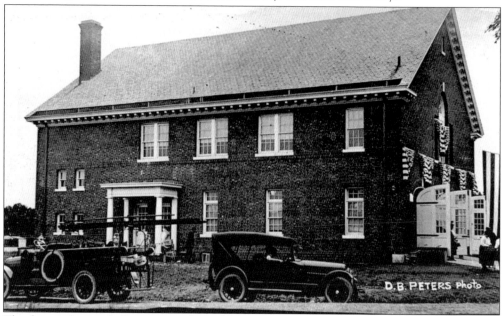

The first real town hall was a simple building when it was constructed in 1921. From 1901, when the Union Academy burned, until 1922, when the township officials moved into this building, township records were kept in office holders' homes. Township meetings, originally conducted in inns and later in schools, were moved to the new town hall. This photograph was taken by D. B. Peters.

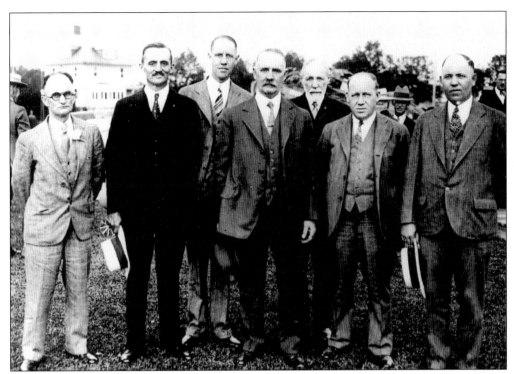

In 1929, ground was broken for a sanitary sewer. Participants included, from left to right, Fred S. Brown; Charles S. Quinsel; Robert D. Treat, township clerk; David I. Jeakens, chairman of the township committee who held the honorary title of mayor; Rev. William Hoppaugh, township tax collector; Gabrial Larsen; and Francis Leslie.

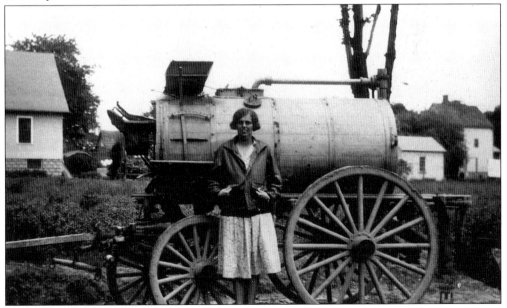

Hannah Hankins Schramm stands beside a water tank being used for road construction on Salter and Brook Streets in Springfield in 1918. She was the mother of Raymond Schramm, who became a commander of Continental Post No. 228 of the American Legion.

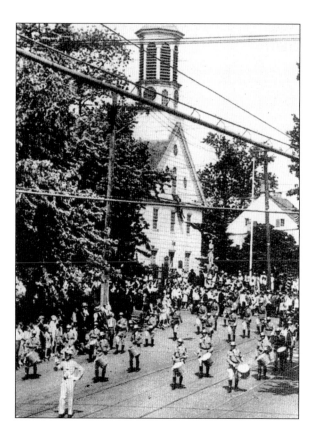

Marchers pass the historic Presbyterian church to begin the sesquicentennial celebration of the battle of Springfield in 1930.

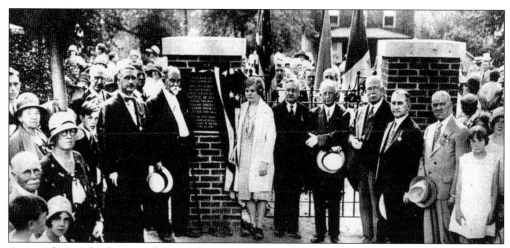

A crowd attends the unveiling of the memorial gateway and tablet at the old Presbyterian cemetery as part of the sesquicentennial celebration of the battle of Springfield. The festivities continued for three days.

Rev. William T. Reed, pastor of the Springfield Methodist Episcopal Church from 1929 to 1933, was the chairman of the sesquicentennial celebration.

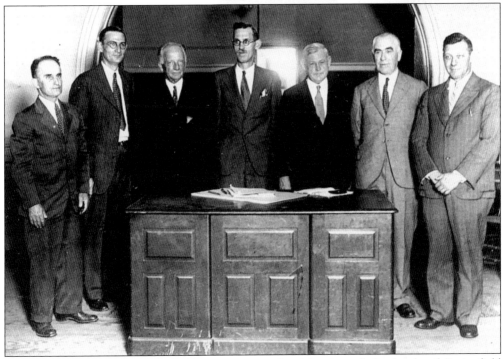

The executive committee for the sesquicentennial celebration of the battle of Springfield included, from left to right, Fred A. Brown; Augustus B. Anderson, secretary; Rev. Dr. George A. Liggett; Charles H. Huff; Rev. William I. Reed, chairman; Joseph H. Gunn; and Nicholas C. Schmidt.

Lee S. Rigby of Springfield served as sheriff of Union County from 1935 to 1938. For a time, he operated the Lee S. Rigby Company in Springfield. In 1937, he appointed Anita Quarles of Plainfield as the first full-time female court attendant and special deputy sheriff. She served as a plain-clothes juvenile court officer until her retirement in the 1950s.

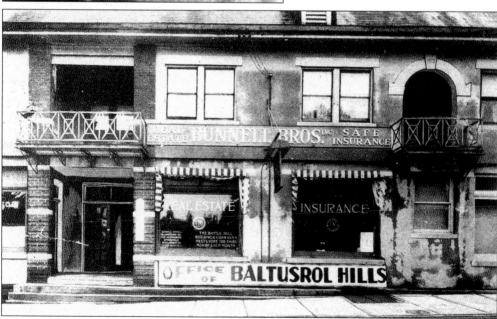

The Bunnell Brothers Real Estate office was in the Brookside building on Morris Avenue. It was the designated sales office for the new single-family housing development called Baltusrol Hills, located along Henshaw Avenue, in 1930. Bunnell Brothers also represented all types of insurance companies.

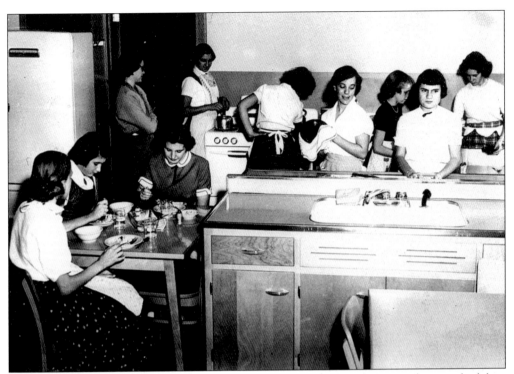

Helen Kilbourne McHale, a home economics teacher, conducts a class in cooking in the lab at the Florence Gaudineer School.

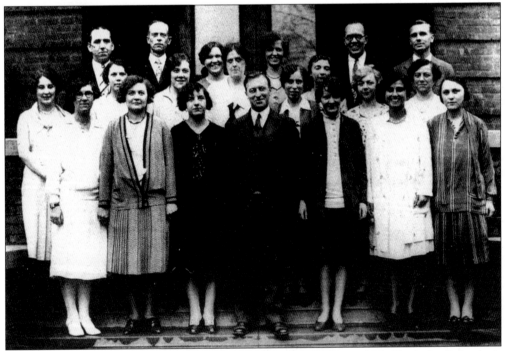

Fred J. Hodgson, principal of the James Caldwell and the Raymond V. Chisholm Schools, is pictured standing in the center of the faculties from both schools.

Thomas F. Clark was called "the mayor of peppermint city" because he operated a peppermint factory at his home on South Springfield Avenue, where he lived for 100 years.

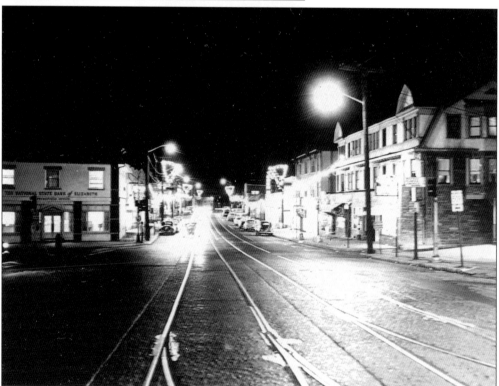

This night photograph of Morris Avenue, taken c. 1925, shows the trolley car tracks in the middle of the street. The Quinsel building appears at the right.

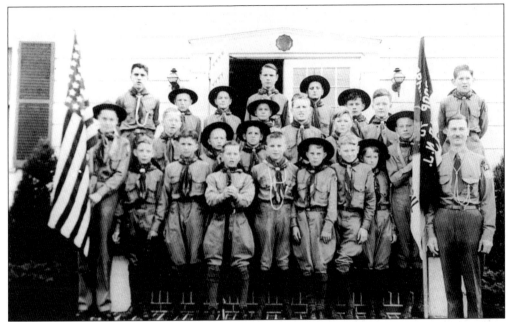

Members of Boy Scout Troop 70 pose for a photograph before the annual Memorial Day parade. The Scouts were among the outstanding youth organizations in the community.

This was used as the clubhouse for the Battle Hill Golf Course, formed in 1929, in Springfield. Continental troops and local militiamen faced British and Hessian forces twice along the Rahway River during June 1780. Thereafter the area was known as Battle Hill. Lawyer Donald H. McLean was president of the new club. Other officers included Dr. G. A. Braun and A. H. Dykes, vice presidents; S. A. Emerson, secretary; and W. A. Sweetland, treasurer.

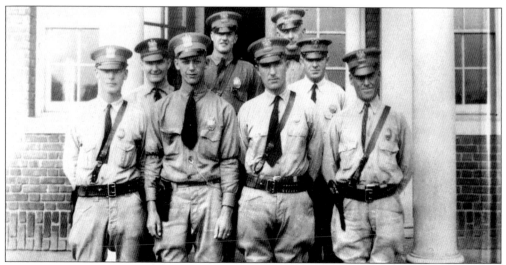

This photograph was taken when the Springfield Police Department formed in 1928. Those pictured, from left to right, are as follows: (first row) Lester Joyner, patrolman; Arthur Phillips; Albert Sorge, chief from 1953 to 1959; and Manning Day; (second row) Albert R. Stiles; Wilbur Selander, chief from 1960 to 1970; Harold Searles; and Chief M. Chase Runyon. Special officers enforced the laws from 1905 until the department was formed, and they became patrolmen. Constables had been in charge of law enforcement prior to 1905.

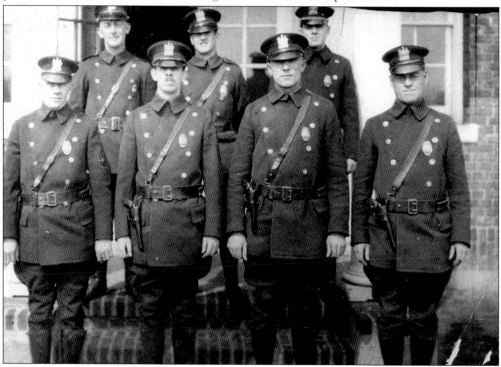

Police officers sport high boots, heavy tunics, and leather belts in this early 1930s photograph. Men identified in the first row include Harold Brill (second from left) and Manning Day (right). Those in the second row, from left to right, are Harold Searles, future chief Wilbur Selander, and Chief M. Chase Runyon.

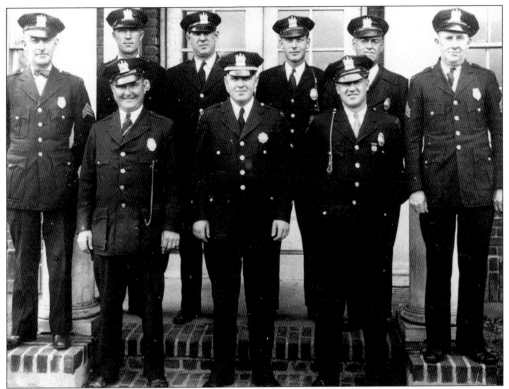

By 1936, the Springfield Police Department had grown. Officers standing on the steps of the town hall, from left to right, are as follows: (first row) A. Nelson Stiles; Chief M. Chase Runyon; and Wilbur Selander, chief from 1960 to 1970; (second row) Sgt. Harold D. Searles; Albert A. Sorge, chief from 1953 to 1959; Arthur Lamb; Leslie Joyner; Manning Day Jr.; and Sgt. William Thompson, chief from 1950 to 1951.

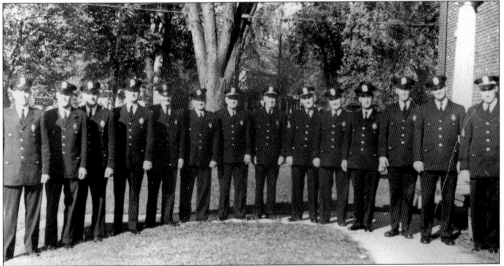

The department continued to grow in the next decade. Here, officers line up around a piece of lawn and by a large tree in front of the town hall and police station. Both the tree and the piece of lawn are now gone. The men are unidentified.

Florence May Gaudineer is seen here graduating from nursing school. According to Howard Wiseman, historian and founder of the Springfield Historical Society, she became acquainted with all children in the Springfield schools.

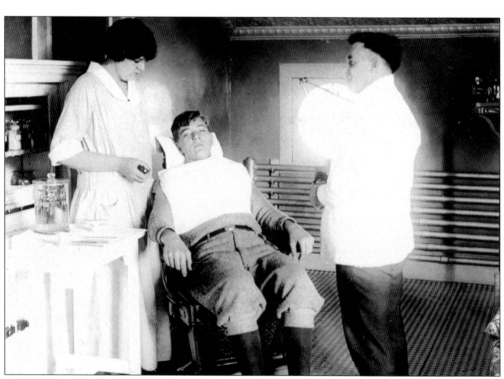

Florence May Gaudineer assists a dentist during an examination of a child at the James Caldwell School. The Gaudineer School was named for her, celebrating her devotion to the children in Springfield.

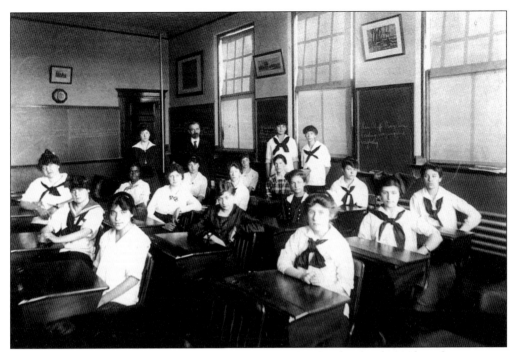

Springfield High School was held in the James Caldwell School, where the administrative office and elementary school were also located. The girls in this class wear middy blouses, somewhat like a man's shirt. The garment had buttons on the front, a V neck and large collar, and long sleeves. The tie had a square knot at the V of the shirt.

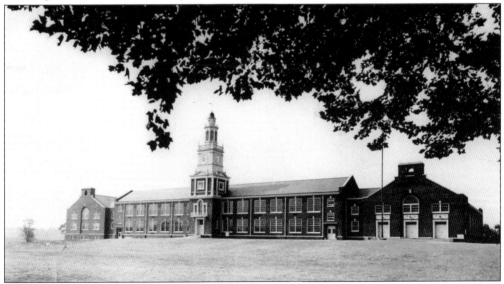

In the mid-1930s, Regional District No. 1, composed of six Union County communities, was formed to organize a high school. The first school was the Jonathan Dayton Regional High School in Springfield, named for the youngest signer of the Declaration of Independence. The building was opened in 1938. The district, which included Kenilworth, Garwood, Berkeley Heights, Mountainside, and Clark, lasted until 1996. The school now serves Springfield alone and is called Jonathan Dayton High School.

Phoebe Briggs was active in the Springfield Public Library for most of her life, both as a volunteer and a paid employee. She also participated in the Springfield Historical Society and served as a docent at the Cannon Ball House. A descendant of the Mulford family of Spring Fields settlers, she wrote a book entitled *Phoebe's Attic*, detailing her memories of Springfield.

Ellen Carmichel and Edward V. Ruby were painted together in this image in the Sarah Bailey Civic Center. Ruby coached football for 20 years at the Jonathan Dayton Regional High School, participated in both the board of education and the township committee, and served as mayor of Springfield. He was in charge of recreation for 20 years. Carmichel was associated with the senior citizen recreation programs.

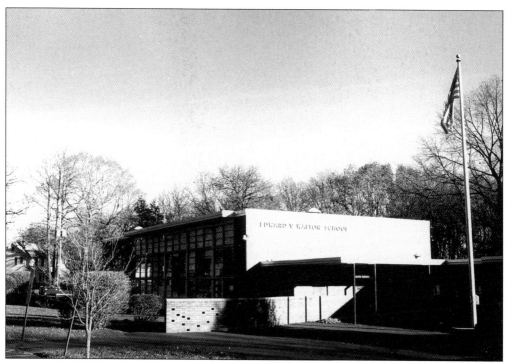

The exterior of the Edward V. Walton School is shown here. Built in 1956, it was named for the superintendent of schools during World War I, Edward Walton, who served the system for 18 years.

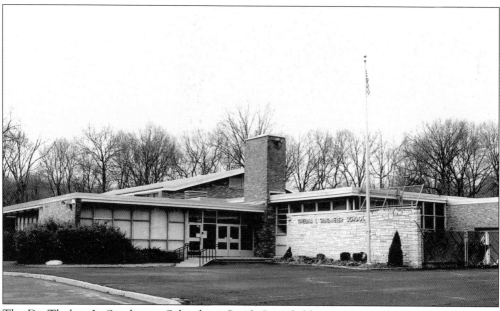

The Dr. Thelma L. Sandmeier School, on South Sringfield Avenue, was built in 1960 and was named for Dr. Sandmeier. She was the former principal of the Chisholm and Gaudineer Schools. The building was erected as one story because it provided more light into the rooms, used less steel, and was safer than a multi-story building.

Members of Continental Post No. 228 of the American Legion work on the post's first regular clubhouse, on North Trivett Avenue. Designed by Arnold Wright, it was dedicated on June 30, 1941, when Mayor Wilbur M. Selander gave the property deed to Henry O. McMullen, chairman of the building committee.

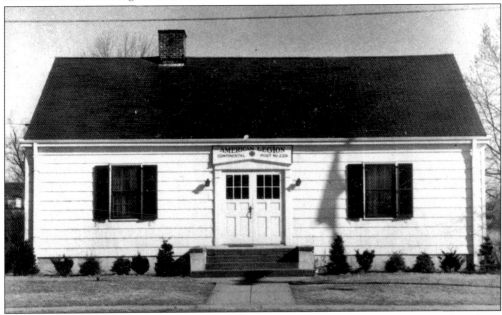

Continental Post No. 228's clubhouse was razed, along with other buildings at the right-of-way of Route 78, in the 1960s. The post moved to the American Legion post home in Millburn, where it continues to meet today.

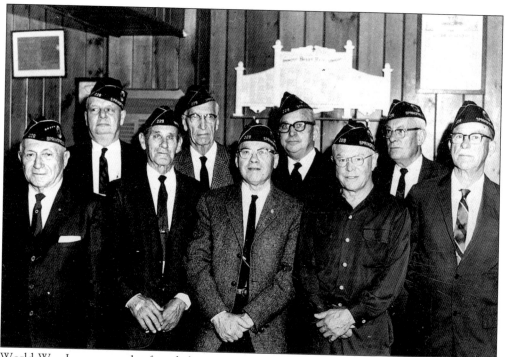

World War I veterans who founded American Legion Continental Post No. 228 in the early 1930s were, from left to right, Alvin Daming, Richard Bunnell, William Geitz, Warren Halsey, James Duguid, Henry McMullen, Clifford Walker, William Young, and John Keith.

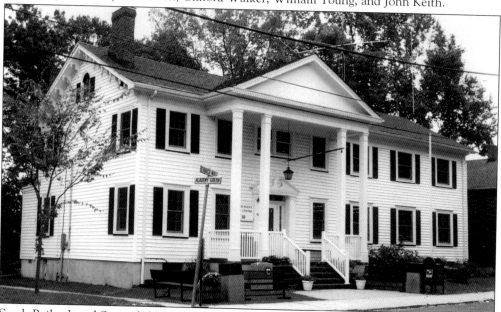

Sarah Bailey loved Springfield. She deeded the family's home on Main Street to the township, and it was used as the library from 1943 to 1969. After the present library opened, the house became the Sarah Bailey Civic Center. It is used for senior citizens' activities and provides space for the township's recreation department. The street's name was changed to Church Mall after Route 78 cut off the rest of Main Street from the center of Springfield.

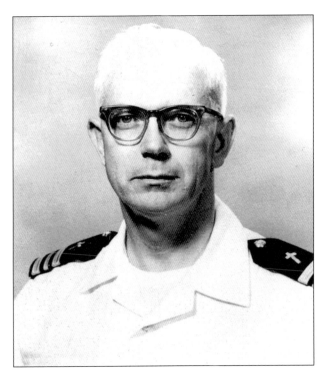

Comdr. Richard K. Titley, the son of Ralph and Elsie Titley, was a chaplain in the U.S. Navy. His parents were active members of the Springfield Methodist Episcopal Church.

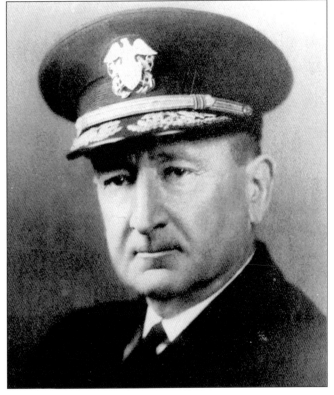

Adm. William Ward Smith of Springfield removed most of the American fleet anchored at Pearl Harbor on December 5, 1941, two days before the Japanese attack. He was a graduate of the old Springfield High School and the U.S. Naval Academy. A plaque was mounted on a bolder in Shunpike Park, now Veterans Park, to honor him.

Walter Kimmerle served with the 49th Regiment, 9th Division, in World War II and lost his sight when he was wounded in Belgium. He was awarded the Purple Heart and the Bronze Star with three clusters.

Rudolph "Sandy" Sandmeier, the husband of Thelma L. Sandmeier (for whom the Thelma L. Sandmeier School is named), was a teacher in the Elizabeth Public School System. He lived in Springfield and served in World War II.

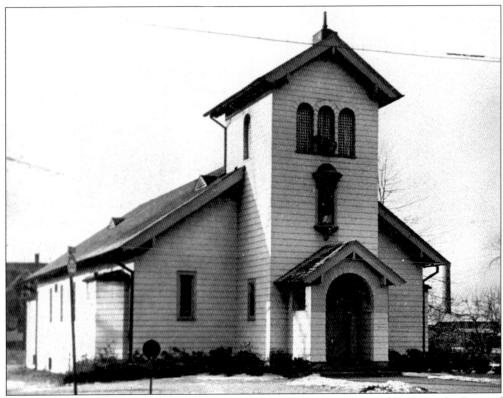

St. James Roman Catholic Church was founded in 1923 by two area churches—St. Rose of Lima Church in Millburn and St. Michael's Church in Union—and by people who met in various Springfield homes. Its first building was constructed in 1925 on Morris and Linden Avenues. The sanctuary was moved to the new St. James the Apostle School on South Springfield Avenue in 1952. The original building became a bank.

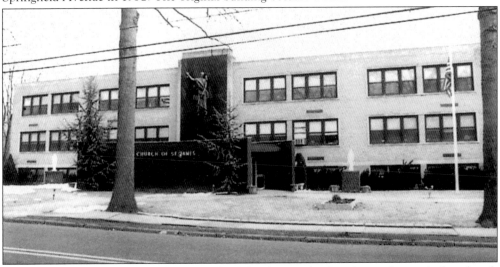

Opened in 1952, St. James the Apostle School contained eight grades and the church sanctuary. The sanctuary was replaced by a church building erected in 2002. Most children now transfer to public high school upon graduation.

St. Joseph inspects the baby Jesus, held by Mary, in this stained-glass window of the new St. James the Apostle Church, which was dedicated on June 6, 2002.

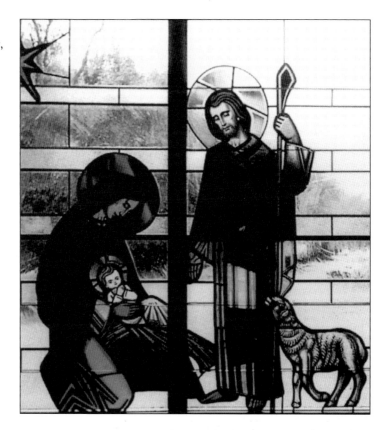

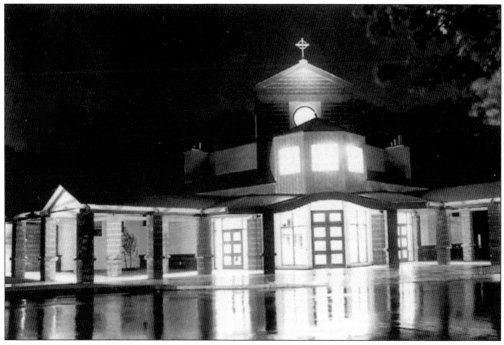

The new sanctuary of St. James the Apostle Church is lighted at night.

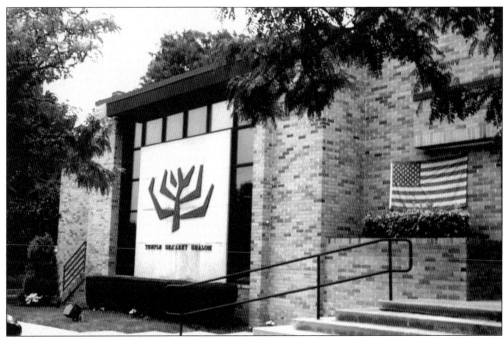

Temple Sha'aray Shalom, a Reform congregation, was organized in 1957. The congregation met in the Presbyterian parish house until the present temple and school were built on Shunpike Road. Rabbi Joshua Goldstein became spiritual leader in 1982. In 2000, Temple Beth El of Elizabeth merged with the Springfield temple.

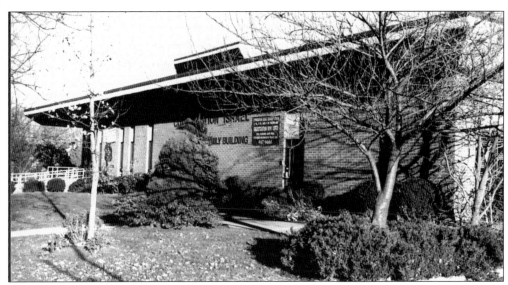

Congregation Israel, at 339 Mountain Avenue, is a descendant of 16 Orthodox synagogues from Newark that formed Congregation Shomre Shabbos on Bergen Street and Watson Avenue and Young Israel Congregation of Springfield. The Newark building closed because Route 78, when built, sliced through the property. The two congregations merged to form Congregation Israel in August 1971.

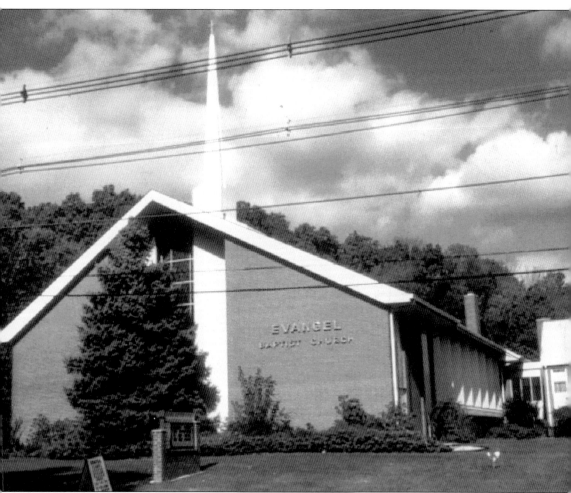

Ground was broken for a new sanctuary for the Evangel Baptist Church at 131 Shunpike Road, Springfield, in 1967. The 115-year-old church was organized by Friederich Hof in New York City in 1852. The German-speaking congregation moved to Newark in 1887 and conducted services in several locations. It remained in Newark until 1967. The congregation of the Evangel Baptist Church spoke German until the outbreak of World War I, when a ban was instituted against the German language. English became the language of the church, which today teaches English as a second language to people from 20 countries. Brotherhood meetings have been conducted with two of the three other synagogues in Springfield. Thanksgiving Eve services were introduced with the Hydewood Park Baptist Church in North Plainfield.

Rev. Dr. Bruce W. Evans was pastor of the First Presbyterian Church of Springfield for 38 years. During World War II, he served with the 18th Seabees in the navy and the 2nd Marine Division as chaplain. He was also pastor of the Townley Presbyterian Church in Union Township and the Crescent Avenue Presbyterian Church in Plainfield.

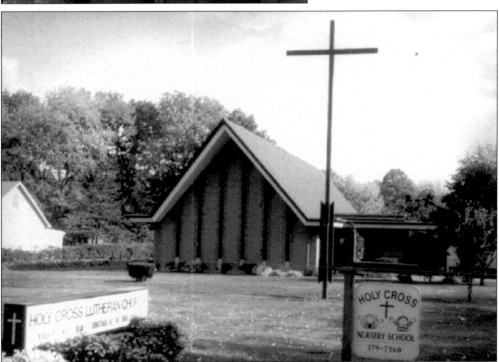

The Holy Cross Lutheran Church, at 639 Mountain Avenue, is one of several churches founded in Springfield after World War II, when Springfield's population increased from 7,218 in 1950 to 14,467 in 1960. The church features a day nursery for children.

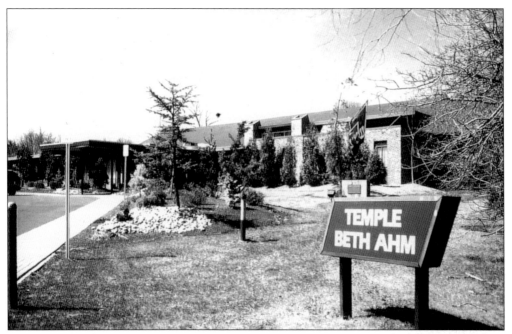

Temple Beth Ahm, a Conservative congregation at 60 Temple Drive, was started in 1955 by Rabbi Reuben Levine. Prior to that, the Jewish people in Springfield had formed a Jewish community group.

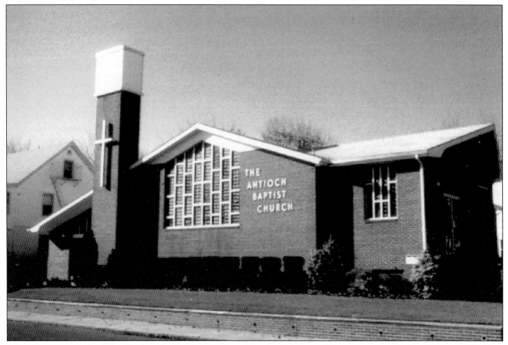

The sanctuary for the Antioch Baptist Church, an African American congregation at Meckes and South Springfield Avenues, was built c. 1970. Prior to that, the congregation met in a small building at the back of the property. The area around the church is called Springfield Fair by the residents. The church is known for its foreign mission work.

Robert Marshal was the first veteran of World War II to become mayor of Springfield, serving in 1952 and 1953. A first lieutenant in the army's infantry during the war, he was awarded a Bronze Star for meritorious service and the Combat Infantryman Badge during his three and a half years of service.

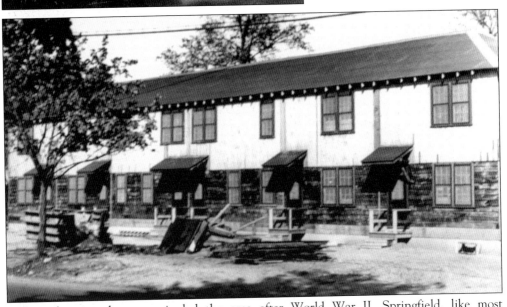

A huge housing shortage crippled the area after World War II. Springfield, like most surrounding communities, attempted to alleviate the problem by erecting temporary veterans' housing. According to Donald Palmer, who gave this photograph to the library, Springfield used this barracks-type building on South Springfield Avenue. It was built or used by the Civilian Conservation Corps (CCC) during the 1930s, according to Hazel Hardgrove, former president of the Springfield Historical Society. After the housing was removed, the Edward V. Walton School was erected on the site.

Mayor Albert G. Binder breaks ground for the exterior remodeling of town hall in 1957. An addition was added 10 years later. Fellow township committee member Raymond W. Forbes looks on.

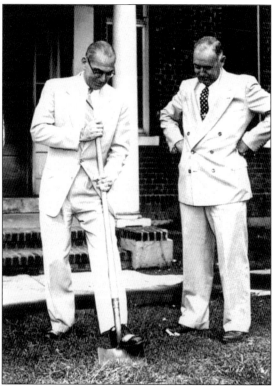

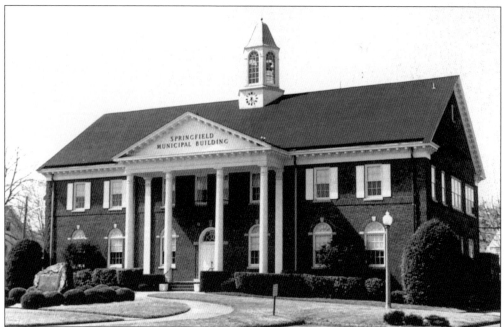

A Colonial style involving six pillars and a peaked roof was added to the town hall during the remodeling of the building in 1957. A clock tower has been added to the roof. The plaque in front of the building honors 20 men who lost their lives in World War II. About 650 township residents served in the war.

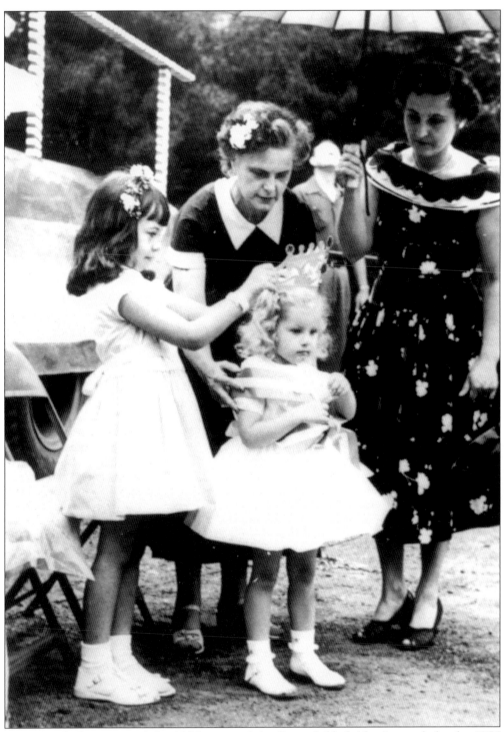

Karen Squilock is crowned the 1956 queen of the Springfield children's parade by the 1955 queen, Jean Beth Haselman (front, left). Mrs. Lee L. Andrews Jr. (left) and Karen's mother, Betty Squilock (right), look on.

# Seven
# SPRINGFIELD AS SUBURBIA

The Spring Fields became suburbia in 1960, with a population of 14,467. Garden apartments such as Troy Village began to spring up. Farms disappeared and were replaced by single-family houses. The threat of the Route 78 freeway slicing through Springfield became a reality as the highway alignment was placed through the township's 20-acre Watchung Reservation and through Sayre Lake, cutting township businesses and residences off from Millburn. While the Watchung Reservation was spared, several hundred buildings were razed and Main Street became Church Mall. Numerous other streets were eliminated or shortened.

Despite these changes, Springfield's population reached 15,740 in 1970, dropped to 13,955 by 1980 and 13,420 in 1990, before rising again to 14,429 in 2000. About one-quarter of the people in Springfield are classified as senior citizens, a higher number than the surrounding communities. The population decrease was due to the 1970 residents' children leaving home and finding places to live outside the area and an increase in the number of one-person units.

Springfield serves everyone. It has playgrounds for children and nearly 1,900 acres of county park land, much of it undeveloped. There are recreation activities for all age groups. Union County College conducts college classes for senior citizens at the Sarah Bailey Civic Center. The library houses the Donald Palmer Museum, and 11 religious sanctuaries serve the township. Route 78 and highways 22 and 24 give people easy access to New Jersey and New York cities. Because of this, many people work outside of the township.

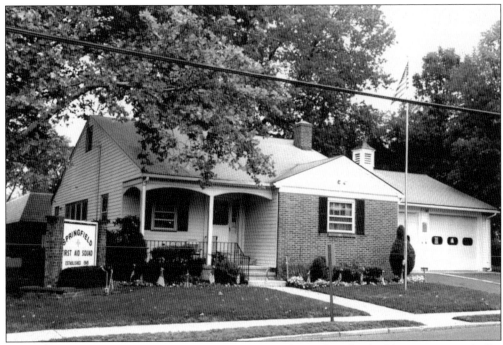

The Springfield First Aid Squad, formed in 1949, was housed in this building near town hall.

Girl Scouts march along Morris Avenue during a parade in 1960. Note that several of the spectators are seated on the curb. Although buses have replaced trolleys, the tracks can still be seen in the center of the street.

C. Henry Caspersen was the president of the Smith and Smith Funeral Home. He purchased the Cannon Ball House and gave it to the new Springfield Historical Society when he died in the 1950s.

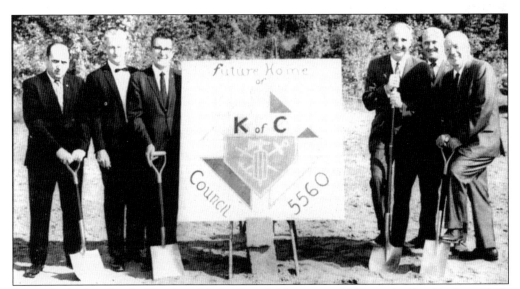

Ground is broken for the Knights of Columbus clubhouse on old Shunpike Road in June 1969. The building was opened in February 1970. The Knights of Columbus became the Monsignor Francis X. Coyle Council. The clubhouse was enlarged in 1986.

These Little Leaguers participate in an all-star game *c.* 1966. Each boy is sponsored by a municipal business. At that time, Jack M. Slater and Donald Lan were coaches of the team.

Route 29 (now 22) is depicted here in 1964. In this view looking eastward from South Springfield Avenue, Channel Lumber appears on the left and the Howard Johnson Restaurant on the right. The highway was built between 1928 and 1933.

Township committee member and future mayor Robert Hardgrove Jr. tries to get fellow member Philip Del Vecchio (left) and Mayor Arthur M. Falkin to test the waters of the new municipal pool in Springfield, when it opened on June 28, 1963.

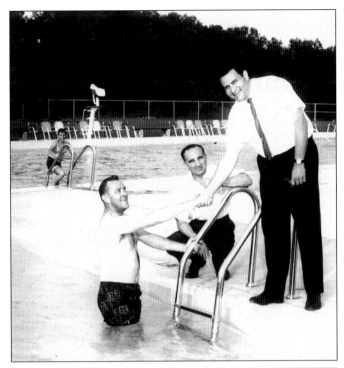

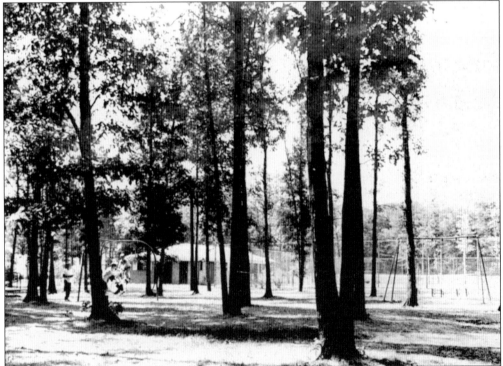

Springfield was covered with forests until the land was subdivided for farms and house lots. In many instances, the trees were left standing when parks were created. This is a view of the Irwin Street Playground in 1964.

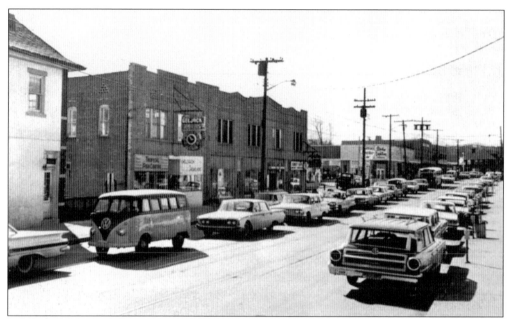

Traffic congestion in downtown Springfield (Morris, Mountain, Millburn, and Springfield Avenues) became a daily nuisance in the township. The township committee adopted a no-parking ban ordered by the state. Residents and businesses along the street protested. Eventually, additional streets and parking lots were installed to lessen the congestion.

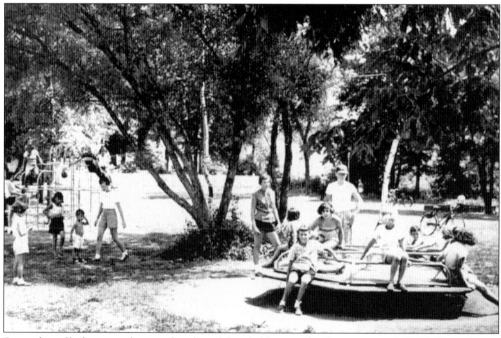

Several small playgrounds were developed for children as the farms were subdivided into house lots. This 1956 photograph shows the playground on Henshaw Avenue. (Courtesy of the Springfield Historical Society.)

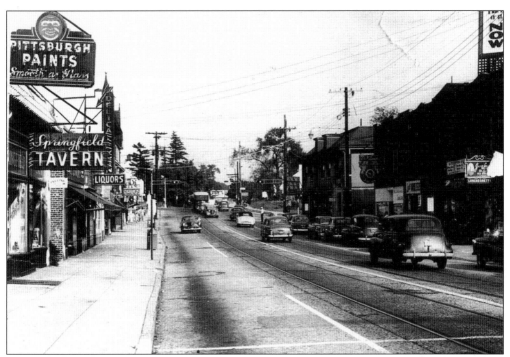

Springfield Center included, from left to right, the Pittsburgh Paint Store, the Springfield Tavern, and a liquor store when this view of Morris Avenue was taken, *c.* 1950. (Published in the *Newark Evening News*; courtesy of the Newark Public Library.)

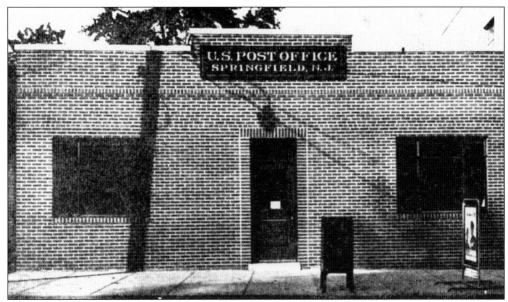

This post office building opened in 1950, 150 years after a postmaster was appointed in Springfield. Earlier post office facilities were located in stores such as Jeakins and Neuman or in an inn. From 1911 to 1943, two post offices were used by the township and were located at the Rahway Valley Railroad Station and a store on Morris Avenue.

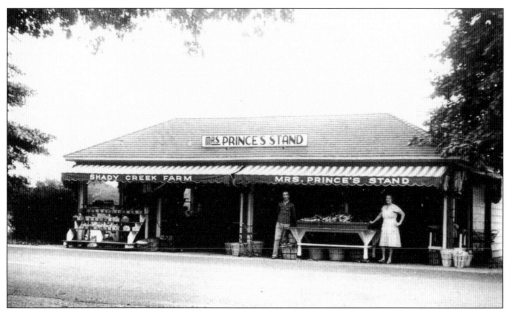

The farm stand of Paul Prince and his wife stood near Route 22 on South Springfield Avenue for many years. Farm stands were a favorite place for city people to purchase their vegetables, fruit, and plants because of the freshness of the produce. Only one stand, Sam's, remains.

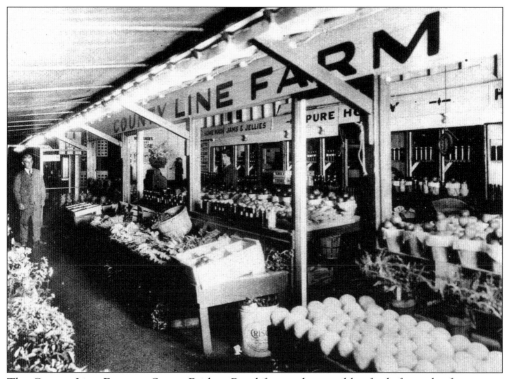

The County Line Farm on Seven Bridges Road featured vegetables fresh from the farm, pure honey, candy, cigars, ice cream, fresh white Leghorn eggs, and cider from the press. J. J. and M. T. Deutsch were the proprietors.

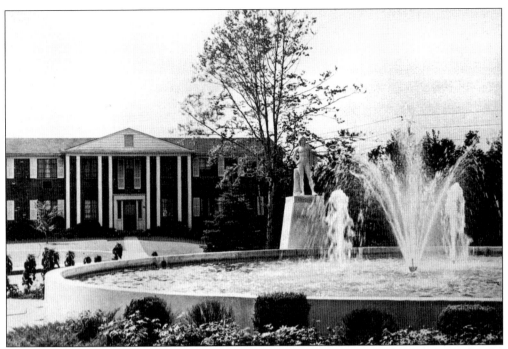

Troy Village was Springfield's largest apartment development in 1962, when a master plan for the township was developed. There are 342 units in the attractive complex. Eleven other garden apartment buildings were listed, making a total of 1,134 units. Troy Village was located in a portion of the Houdaille Quarry. The quarry was originally owned and operated by Stewart Hartshorn, the founder and developer of Short Hills.

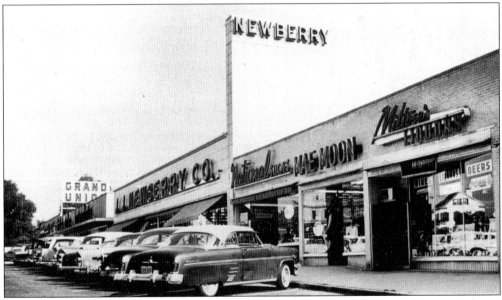

The General Greene Shopping Center, named for Gen. Nathanael Greene, who was in charge of troops during the battle of Springfield on June 23, 1780, is pictured here in 1964. The stores included, from left to right, the Grand Union Supermarket, the Newberry five-and-ten, National Shoes, Mae Moon, and Milton's Liquors.

Edward Townley, who lived more than a century, was a charter member of the Springfield Auxiliary Fire Department, which was formed in 1910. Townleys were among the earliest settlers of Elizabethtown.

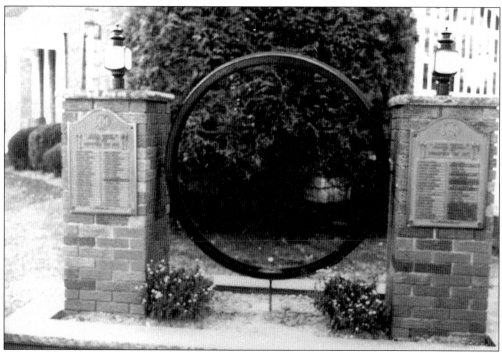

This memorial contains the names of all fire department members who have died. It has since been moved from the town hall to the new firehouse on Mountain Avenue, which was dedicated in March 2004.

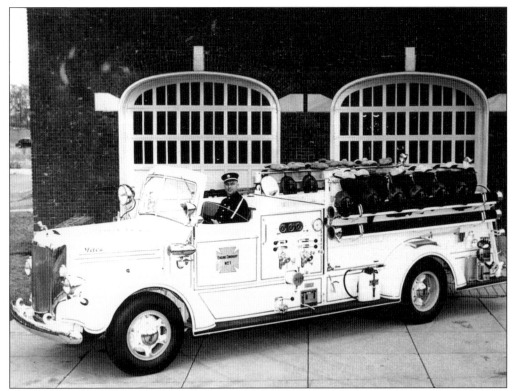

The Springfield Volunteer Fire Department used this white pumper. It was kept in the fire department's garage at the back of the town hall.

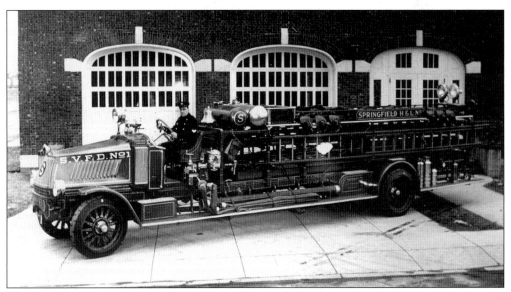

Hook and Ladder Truck Company 1 operated this vehicle for the Springfield Fire Department.

Pamela Blafer Lack was awarded a humanitarian medal by the Vietnamese government for her aid to homeless children in that country. She became interested in the Shoeshine Boy Foundation through a fellow student at Boston University and helped to establish homes for the homeless children in Saigon and Da Nang.

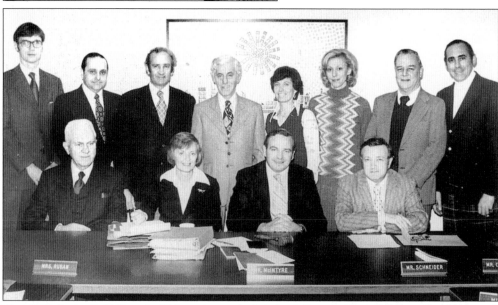

The 1973 Springfield Board of Education included the following, from left to right: (first row) attorney Howard Casselman, secretary Audrey Ruban, president Michael McIntyre, and vice president Zachery Schneider; (second row) James Adams, superintendent of schools Dr. Fred Baruchin, George Doty, August Caprio, Irene Koppel, Joanne Rajoppi, Robert Southward, and Scott Donington.

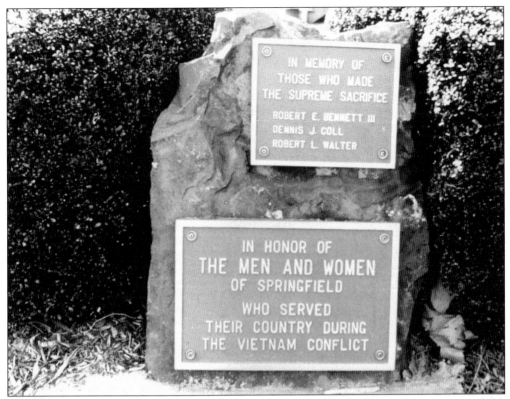

These plaques for veterans of the Vietnam War are located in front of the town hall in Springfield. Three Springfield men died: Robert E. Bennett III, Dennis J. Coll, and Robert L. Walter.

Jerome Josephs served in Vietnam for 26 months starting in 1967. He was a medic in Da Nang with the U.S. Marines. After he left Vietnam, he was stationed in Greece until his discharge.

Becky Seal was honored by the senior citizens of Springfield for her work on behalf of the group in 1976.

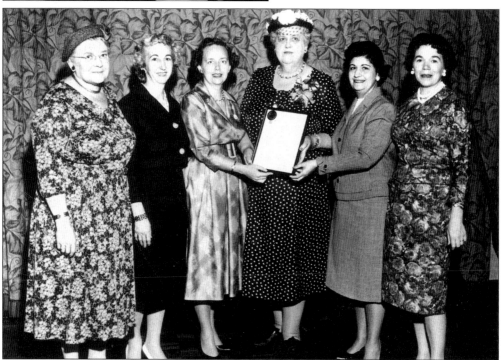

Florence Gaudineer is honored by the New Jersey Federation of Women's Clubs at the 1966 annual convention in Atlantic City for her outstanding work with the children of Springfield. Pictured in the photograph are, from left to right, Harriet E. Smith, a friend; Mrs. Walter Anderson; Mrs. Robert Hardgrove Jr., president of the Springfield Women's Club; Florence Gaudineer; Mrs. Vincent J. Bonadies; and Mrs. Kenneth Bandoner.

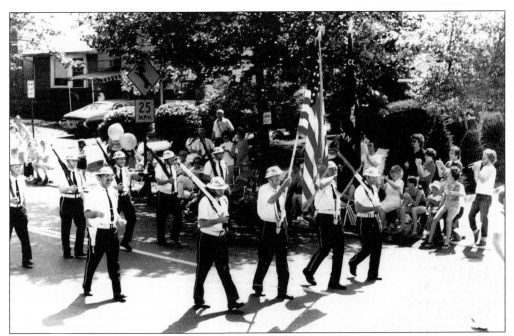

Members of Continental Post No. 228 of the American Legion march in the nation's bicentennial parade on July 4, 1976.

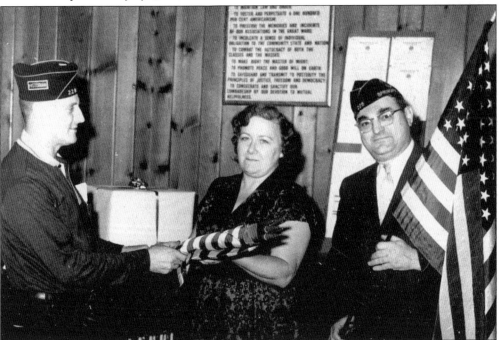

A 50-star flag is presented by Alfred Rutz of Continental Post No. 228 to Elsie Kisch, representing the Girl Scouts of America, in ceremonies at the post home on January 29, 1961. Frank Sammond, post commander, watches. The presentation was part of the post's Americanization Program. The post also purchased the township's first ambulance and lobbied for the construction of the present post office.

William Gural, former deputy attorney general of New Jersey and chief rate counsel for the Public Utilities Commission, has served as judge in rate cases in recent years. Gural was the mayor of Hillside before he moved to Springfield in 1960.

Harold Ackerman was appointed a Union County District Court judge in May 1965 and was named a Superior Court judge on June 18, 1973. He retired on January 1, 1980, to accept an appointment to the U.S. District Court.

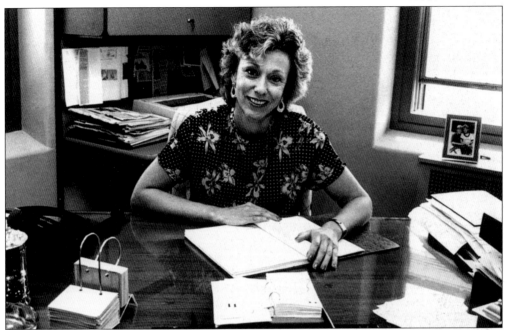

Joanne Rajoppi is now the Union County clerk. She was a reporter for the *Newark Evening News*, a member of the Springfield Board of Education and the township committee, and, in 1977, the community's first woman mayor. Rajoppi has also been assistant secretary of state for New Jersey. Having already written a book, *Women in Politics: Getting There and Staying There,* she is currently composing a novel.

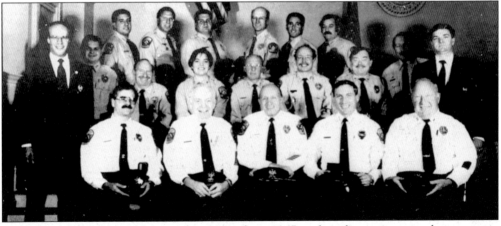

When a civil disturbance occurred in Newark in 1967, police departments in the area were requested to send officers to assist in restoring peace. This meant that townships such as Springfield would be without police. In order to prevent this, an auxiliary police force was formed. Today, they serve with regular police in crowd and traffic control. Pictured here in 1994, from left to right, are the following: (first row, seated) Lt. Mitch Janklow, Chief Harold Liebskin, Capt. Harry Vargas, Lt. Jeffrey Katz, and Lt. Harvey Taub; (standing, left) John Cottage; (second row) Angelo Palumbo, Ronald Mitnitsky, Eileen Brumley, Tony Wunderlich, Marc Marshall, Sgt. David Clark, and Bernie Kotler; (standing, right) deputy coordinator Scott Seidel; (third row) Ralph Carpini, Sgt. Richard Lippman, Jack Vogel, Jim Bonacorda, Jeff Demuth, and Gary Butler.

Former presidents of the Springfield Historical Society stand on the lawn of the Cannon Ball House in 1976, after the house was placed on the National Register of Historic Places. Shown here, from left to right, are Howard Wiseman, George Benson, Eva Brown, Madeline Lancaster, and Howard Casselman.

Howard Wiseman, a founder of the Springfield Historical Society, works on a display. Wiseman, to whom this book is dedicated, devoted his entire life to the study and preservation of American history. Most of all, he was a teacher. He encouraged others to write about history and, for about 20 years, was the chairman of the League of Historical Societies' program to judge the best historical books, pamphlets, and newsletters published in the state. Serving as a researcher in the Newark, Maplewood, and Springfield libraries, he assisted many authors. He arranged exhibits for the Donald Palmer Museum and frequently spoke to groups about New Jersey's history.